D0426818

PAUSE

A SKETCH BOOK

PAUSE

A SKETCH BOOK

By

EMILY CARR

Toronto Vancouver
CLARKE, IRWIN & COMPANY LIMITED

COPYRIGHT, CANADA, 1953

by CLARKE, IRWIN & COMPANY LIMITED

ISBN 0-7720-0118-9

Centennial Edition, 1972

3 4 5 6 JD 76 75

Lithographed in Canada
by Ronalds Federated Graphics
Bound by
John Deyell Limited

CONTENTS

CONTENTS

ILLUSTRATIONS*

* *By permission of Ira Dilworth from a sketch book in his possession.*

ILLUSTRATIONS

P A U S E

A SKETCH BOOK

AUTHOR'S NOTE

The Fat Girl and Her Failure

The fat girl came from the far west where the forests are magnificent and solemn but no singing birds are there. The fat girl found birds in the early days of her sojourn in England. She heard a thrush sing. It was a poor prisoner in London, broken tailed and bedabbled, in such a dirty cage, but the pure song coming from its dreary prison touched the fat girl. By and by illness came and the fat girl subsided into a San with a limp and a stutter. Then it was that the plan came to her to rear some thrushes and take home to her glorious silent woods. The fat girl bucked up. Spring came, birds built. The fat girl waddled forth with her stick and watched for many weeks the pretty mothers build and sit and hatch their clean and ugly babes.

The Sanatorium,
Nayland,
Colchester,
Suffolk,
March 1903.

CONDEMNED

THE Harley Street Specialist pretended that he had not noticed me lay his fee in gold upon his desk. He hoisted his well-satisfied self onto the toes of his shiny patent-leathers, and forcefully repeated, "Madam, the voyage to Canada is for the present entirely out of the question. Best of care, rest, rest, good food, above all fresh air . . . you are young. . . ."

"But Doctor—?"

"You have people this side of the world?"

"No one."

"Who looks after you?"

"I look after myself."

"Inadequately. Sunhill Sanatorium, that is the place! Doctor Sally Bottle, Lung Specialist, Harley Street. Arrange with her for a year's stay in the Sanatorium. A year's rest and care will do wonders. Good day."

"But Doctor, I am not T.B. I came to London to study Art. I've just worked too hard, that's all."

"Precisely." He rang for the maid to show me out.

"A year!" I stumbled down the steps of the Specialist,

made my way to Doctor Sally Bottle's. Within twenty-four hours I was seated in the train, bound for Sunhill Sanatorium, wildly rebellious at heart.

I was met at the station by James, sole male worker around the Sunhill Sanatorium. From doctors to 'Odd Jobs' the entire staff were women.

"Sun'ill, Miss? 'Osses is be'ind 'ere." He gathered up my luggage.

The seat of the San bus was shaped like a horseshoe, intimating luck to San curings, perhaps. At the back, across the opening of the shoe, were two iron steps. To keep you from falling off the horseshoe cushion, it was circled at about the height of your shoulder blades by a narrow strip of upholstery mounted on an iron rail. The bus was drawn by a pair of meek grey horses. James woke them, boosted me up the two iron steps, tossed a sack of mail at my feet, and from the back called "Gidaap"; by the time he had leisurely walked round to the driver's seat the horses had each put one foot forward.

Low hillocks puckered the face of the land; everything was fast whitening under a turbulent snowstorm. I was soon white and shivery. There was no protection under the horseshoe seat and none over top. The wind did what it liked with you. It was useless to tuck your skirt round your legs. You were lucky to be able to sit on the top part of your skirt or the thing would have

6

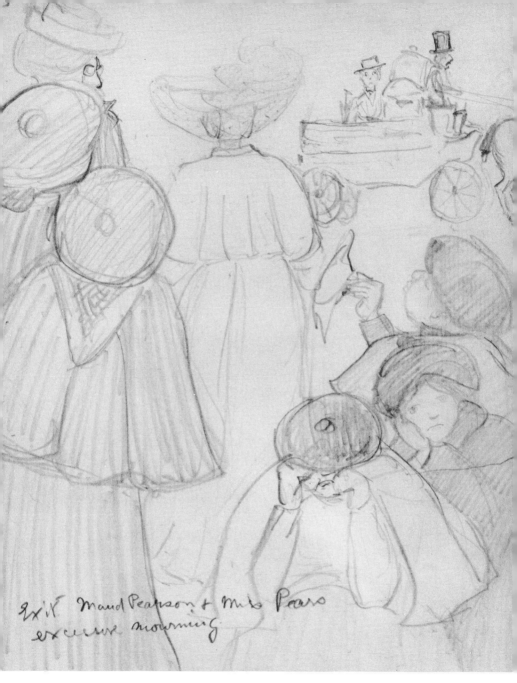

The Horseshoe Bus

flown away altogether. The greys pulled slowly up the little hills. The weight of the horseshoe bus pushed them down again ready to climb the next. Our wheels made lazy zigzag trails on the white road.

We kept overtaking slow-moving little groups of red-nosed men and women with bare blue hands. "Why don't they hurry a little to keep warm?" I asked of James.

"Dassen't, Miss. Lungs is all in tatters. Doctor'd fix 'em proper if they was to 'urry. Most all 'ere is T.B. Cook now, and Doctor is sound. The rest on us—!" He produced a cough, as intimation.

"That's 'er, Miss." James pointed with the whip, as it returned from a gentle lag over the backs of the greys, just to remind them that they were dragging the big horseshoe bus along the road and not standing in their stalls. "Sun'ill San! there she be."

Sunhill Sanatorium stood on a grassy bump hardly worth the name of hill. It had a chunky body and two long, long wings, spread, drooped slightly forward so that every window could catch its share of sun during the day. It was now covered in a drape of snow, not a sign of life anywhere; it lay in horizontal deadly flatness, having the cower and spread of a white bird pausing, crouching for flight. This cold white place was approached by a long straight drive. I learned afterwards that I had come during the evening Rest Hour, five to six o'clock. Every patient lay upon his bed resting, the

House Doctor was making visits from room to room, and nurses were preparing supper trays for their bed-patients.

Matron came out of a tiny office near the door meeting me with a broom and sweeping snow from me. Then she swept James and bade him carry in my luggage. She rang for a nurse who came with a wheel-chair and insisted that I get in and be wheeled down one of the long, long corridors in the wings to my room. I would have preferred to walk.

My room had no front. From the ceiling to a foot above the floor it was open to the turbulent snowstorm. All the patients' rooms were on the south side of the corridors; the north side of each corridor was all open windows, the wind roared down with hurricane velocity. High over our beds was a row of small windows opening into the corridor; patients were forbidden ever to shut windows without permission. A draft swept across the ceiling of patients' rooms continuously. It was colder in the rooms than outdoors. The nurse asked, "Did you bring a hot bottle? There is a stone pig in your bed." She shook a mound of snow off the counterpane and showed a smaller mound underneath not warm enough even to damp the snow. I crawled into bed and stuck my frozen feet against the hard cool thing. Hoping for something better when the nurse came back with my rubber bottle I found she had filled it with only tepid. I wanted to scream, "Boil it, boil it!" but she was gone, clicking off the light. I was in the cold, the dark. A year

of this! I turned into my pillow and cried. It seemed the only logical thing to do.

Suddenly my room was full of light and an abnormally large woman stood by my bedside. I stuck out a snivel-red nose.

"Any temperature?"

"No."

"Cough?"

"No."

"What ails you? Doctor Bottle sent no instructions. She will be down herself tomorrow. Meantime, what's the good of crying?"

"Who could help crying in this most horrible place? My people are all in Canada. The Doctor says I must have a year's rest before I can travel. I've worked too hard." I dived under the bed-clothes again.

Doctor McNair was Scottish by birth. Her tongue clung still to the Scots but her ways were English. She was London trained and wished to acquire English professionalism. She stood by the heaving lump in my bed

Promenading in the corridor upon a windy day
Is enough to turn hair red or gold
To purest white or grey.
Blow, blow, ye merry winds of March,
Slam every hinged door
And when we take a little walk
Blow, blow ye all the more.

Promenading in the Corridor upon a windy day
Is enough to turn ~~the~~ hair red or gold
To purest white or gray.
Blow Blow ye merry winds of March
Slam every hingèd door.
And when we take a little walk
Blow Blow ye all the more.

for a minute or two but I did not come out till she asked the surprising question, "Do you smoke?"

"Why, a little," I admitted, "but I did not expect to be allowed to here."

"I'll be in after supper and have one wi' ye." She was gone.

A maid in scarlet with a frilly white cap and apron hummed in and clattered, hummed out and clattered, swinging her implements. Nurses started pattering up and down the corridor, clanking trays, banging doors. They could not help it with a typhoon raging in the corridor. I humped my knees up to throw off the snow that had drifted in afresh. My supper was wheeled up across the top of the bed.

Doctor came after supper, smoked one of my cigarettes and approved the brand.

"Ye'll reconcile to the place after a wee bittie," she said, and left me in the dark. Snow was still falling. Wind howled. "Please couldn't you make them a little hotter?" I pleaded when the nurse filled the hot bottles for the night.

"That is regulation," she said coolly. I kicked their clammy uncomfortableness onto the floor. They chilled what little warmth there was in me.

I heard a scrabbling sound over by the bureau. Prickly with nerves I darted for the light switch. There, perched

Just as you're feeling better
And joy your bosom fills,
Down falls your heart to zero
For in comes nurse with pills.

on top of the mirror was a tiny brown bird. At the light click she took her head from under her wing and looked at me. After one sleepy blink she put it back.

The little bird in my room made all the difference. I slept fitfully, turning on the light every while to see if she were still there. Her coming unasked was so friendly, so warming. Next morning a robin breakfasted from my tray.

Stupid, stupid Doctor Sally Bottle, praising this and that about your old San, omitting to tell of the chiefest, most joyous thing—Sunhill's birds.

SUNHILL SANATORIUM

THE Sunhill Sanatorium belonged to a company. It consisted of Doctor Sally Bottle and a handful of non-entities who gave sums of money to Dr. Bottle to turn over for them.

Doctor Sally Bottle was as omnipotent in the company as she was omnipotent in the San. She rushed down from her Harley Street office late Friday night and took hold, returning to London late Sunday night. Doctor Sally filled not only the San with herself. She filled every corner of the property—a large acreage. Dining room, kitchen, garden, fields, home-farm, even the tiny morgue, where they hid away the dead that we were supposed to know nothing about—Doctor Sally Bottle dominated all.

They gave us very little credit for having sense in Sunhill. We came here to pause our ordinary activities. Even thinking was prohibited. Doctor Bottle's brain worked for all the fifty patients and even for Donkey Jinny who mowed the lawns of Sunhill, her feet laced into two pair of human boots. It was Dr. Bottle's com-

mand that Jinny wear boots, an indignity to Jinny's dainty hooves. Jinny invariably gave a derisive bawl when the meek greys plodded up the driveway with Doctor Sally behind them in the horseshoe bus. Jinny was the only creature who dared voice a come-back at Doctor Bottle.

During her visit the oversize resident Doctor shrivelled. To the naked eye Doctor McNair was a vast woman. Her bulk was only flesh and blood; her voice was thin and meek, her decisions wavery, her eye unobservant. She was pompous and over-masterful to the staff. When she was in charge, she wished it remembered that in Doctor Bottle's absence *she* was official head. Among the patients she showed favouritism. (I happened to be one of her favourites so I do not say this for spite.) It rather amused us to see Dr. Mack sink like sediment beneath the swirling ferment of Doctor Bottle's activity during weekends.

It was scarcely light on Saturday morning when we heard the procession advance upon the sleepers. The procession started from the Doctor's office. Windows along the corridors had stood open all night, and were open now to the early morning chill. Dr. Bottle in a stout stuff dress of plum colour buttoned to the chin bustled ahead clap, clap, clap. She had large feet, the kind that slap the floor with every step, iron-grey hair, coarse and smeared back to an onion at the nape of her neck. The wind took liberties with Doctor Sally's hair,

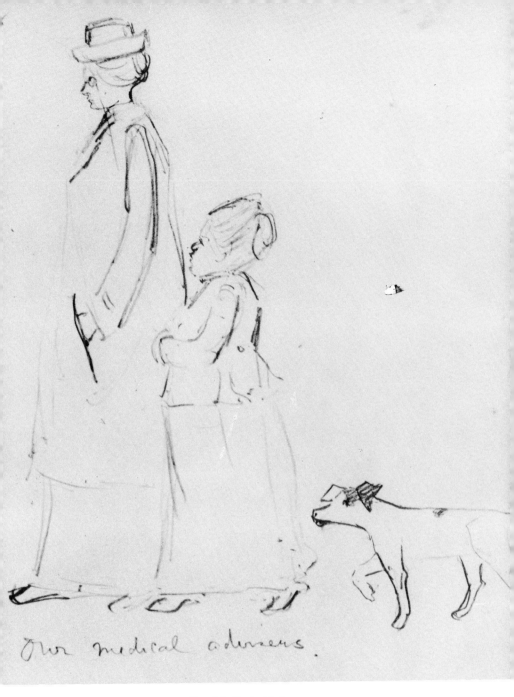

Our Medical Advisers

Saturday Morning

streaming it three or four inches ahead of her face. She was always blowing or pushing it back with hands or lips. Behind Doctor Sally in the procession came Nurse Pickwick, trundling a heavy iron scale on wheels—the kind of scale butchers use to weigh carcasses. Doctor McNair, meek-voiced, long-legged, clasping the Doom Book in both hands, tailed the lot. The scale halted at each door, stopping with a screech. The door opened, out came a scantily-clad patient, stepped onto the scale's iron platform, first kicking the woolly shoes from off her feet. Nurse Pickwick adjusted the weights. Doctor Bottle read the tally. Doctor McNair made entry in the Doom Book. If there was no gain the patient slunk back into her room without comment. If there was loss, the Doctors wagged their heads and the victim knew there would be an increase in the size of her helpings at table, vastly oversize now for any normal appetite.

Nobody lingered over their dressing in these icy rooms. Through winter's coldest, her wettest days, only one half hour of heat was allowed to unchill the registers night and morning against freeze-ups, not to unthaw us. The great dining-room was open to the weather on three sides. I was not permitted to get up for breakfast. All those red noses and purple hands must have looked pitiful. My own meals were moderate enough: I was not T.B., I was not under weight.

Because weighing delayed patients dressing, on Saturday morning they were excused if they were a little late.

21

Immediately after the meal the two Doctors went to the office and hung great stethoscopes like glorified wish-bones round their necks. One by one the lung patients submitted to soundings and tappings. From these lung soundings I was exempt, but my heart got them good and plenty later.

Patients were graded as 'Downs', 'Ups', and 'Semis'. 'Downs' kept their beds; 'Semis' spent part of each day lying in a long row of reclining chairs on the Circular Porch, or on the gravelled terrace just below the open fronts of the patients' rooms; 'Ups' had begun to respond to treatment, went to meals in the dining-hall, and took prescribed walks, so many hours (or was it minutes?) to the mile.

The Sanatorium was built in the form of a cross. In the body of the cross were dining-hall, kitchen, offices. To the right and to the left of the body were the long wings two stories high. All the patients' rooms were under these wings or arms. Between them projected a circular brick-paved porch, as it were the head of the cross. Doctor McNair's office had a window opening onto the Circular Porch so that serious patients were always under her eye. From her room she could look down the right and left terrace, see the long rows of reclining chairs.

The 'Ups' assembled on the Circular Porch to await tea and rest-bell. Twelve to one and five to six were San

Rest Hours when every patient lay and was still. From her window the Doctor could time the coming back of each patient from his walk, note if he had over-hurried or dawdled, by timing his arrival on the porch. Everything was horrible clockwork, tick tock, tick tock. You felt like a mechanical toy.

Nothing but cheer was permitted in the corridors. If a patient had a huge misery, knew she must cry, she ran to her room under the San's long brooding wings, ducked behind her scant dressing screen, gave way. It was more indecent to be seen crying in the San than to be seen naked.

New patients soon caught on to the San code: T.B. taboo, symptoms taboo, grumbling taboo, mention of death taboo of taboos. Of course, there were the few who could and would talk of nothing but themselves and their disease, but they soon discovered they were shunned.

Pickwick, Bandley, Brown, Bunker, Maggy, Ada, and a nondescript creature known as 'Odd Jobs'—this was the San's nursing staff, with Specials sent from London when they were required. Old Pickwick was a certified nurse, the rest though apparently in good health were ex-T.B. patients, whose lungs were still owned by Dr. Sally. In return for keep and treatment they nursed under the supervision of Matron Lovat. Nurse Brown was my nurse, a sad prim soul whom I promptly nicknamed Jokey Hokey. At first she protested, because not

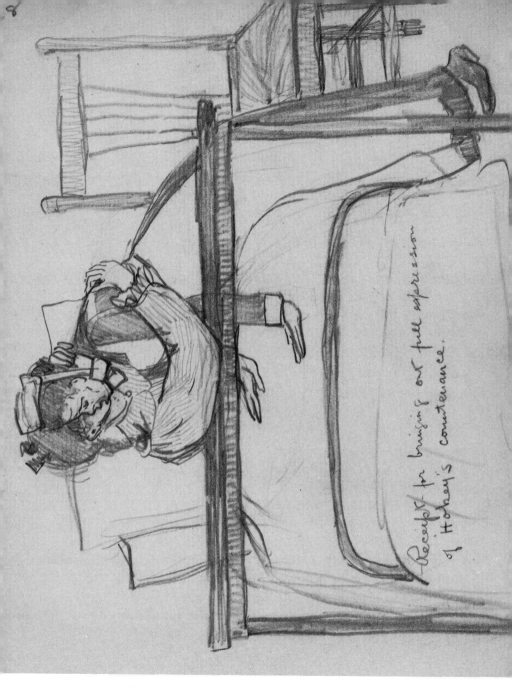

Receipt for bringing out full expression of Hokey's countenance

being trained 'regulars' our nurses were more particular than ordinary about professional etiquette. Soon Nurse Brown warmed to my pet name, permitting me to 'Hokey' her providing I did not do it in public.

I read my own behaviour in Hokey's face. If I was suffering, it was sad; were I provoking or contemptible, Hokey's face set like a junket. When I was simply impossible she went away and left me.

A habit that English nurses had, that of calling their patients 'Dear' from the moment they came on a case, annoyed me tremendously. Hokey deared me just once.

"Don't do that to me," I shouted. "I won't be 'Dear' except to those who mean it and to whom I am dear." Hokey never deared me again; when I was being dear, though, she would give me one of her rare sweet smiles.

Pickwick because of her certificates was bumptious and unpleasant. Bunker had a puffy face, fallen arches and wheezy breath. Maggy was short, snorty, and religious. She devoted herself to the Cranleigh boy who was very ill. Each nurse had one specially serious case. The 'Ups' and the 'Semis' did not require much care. Hokey's bad case was old John Withers.

Last and least of the nurses was Ada the Quakeress, who smashed all my ideas of Quakerism. She burst into the room in a sky-blue dress. All the other nurses wore navy serge, and white caps and aprons. The San was much too cold to wear white starched uniforms. The Quakeress wore this razzle-dazzle blue, was loud of voice,

25

a door banger, a soup slopper. She nipped snacks of food off patient's trays, and screeched if she saw an insect. The rooms being so open, all sorts of creatures naturally found their way in. I loathed Ada the Quakeress.

Beyond all ranking, at the tail of the list came 'non-descript', neither nurse, maid, nor patient. Her neck was a continuation of her lean cheeks; she had no chin, she had sly eyes which skidded. This creature went by the name of 'Odd Jobs'. The nurses called on her inefficiency for bits of help if they were extra busy.

Under a cheerful crust there was something wistful about our nurses; maybe it was constantly watching the finish of that which tainted their own lives. They could not go in for regular hospital training; most of them knew they were just marking time. When five years later I met an old San patient in Paris and enquired for nurses and patients, one by one, only in an occasional instance would the old San patient say, "He was cured." It was, "Did you not know T.B. got him in the end?" She told me that the treatment had been very much modified since my San days.

The men patients at Sunhill Sanatorium kept to themselves, enjoying a grouch. They made me think of a little band of ducks in a big hen yard. Someone had advised their seeing the Big Lung Specialist, Sally Bottle of Harley Street. Of course Doctor Sally advised Sunhill San at once. "Just a few weeks in the open air in

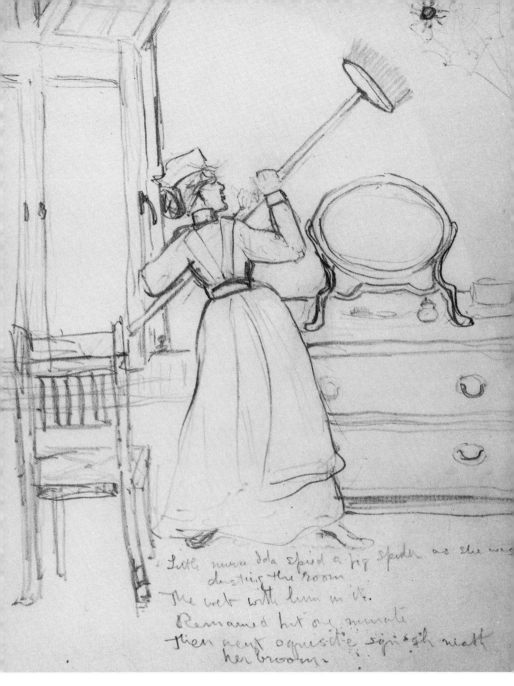

Little nurse Ida spied a big spider
As she was dusting the room.
The web with him in it
Remained but one minute
Then went squis-it-e, squish, 'neath her broom.

that lovely part of England, there you were! well again!"
She kept them in bed for some weeks, according to the
severity of their case. Then they were promoted to
'Semis' and put to lie in a lounge chair on the terrace.

It was then that they found out, and their fury boiled!
Twenty women to every man, rows of red-faced woolly-
clad women, aggressively cheerful. The men scuttled
into being 'Ups' with all possible speed, to get away
from the women. They grew beards, quit the terrace,
herded on the lawn, or walked in an angry group.

The lungs of the 'Ups' underwent a thorough over-
haul every week. That was the time patients saved for
questioning, because during examination doctor and
patient necessarily were close. The patient quavered.

"Doctor Bottle when—?"

"Hold your breath."

"Please, Doctor Bottle—"

"Double over."

"But, couldn't you tell me—?"

"Next!"

The questioner had to wait till Rest Hour to try and
get a hearing, but Doctor Bottle held the latch of the
door in her hand in spite of the draught that nearly blew
the hair off her head. "How are you? How are you?"
Blithe and without waiting for an answer she was gone.
Lung healings are slow. Probably Doctor Bottle did not

Men

know herself, but it was disheartening for patients. By and by they stopped asking.

Everyone loved Matron Lovat. She faced things, had the courage of a cook who plunges a clean blade into the middle of her cake to test, rather than nibble round the edges. She was quiet and understanding, had none of that mock cheer the rest of the staff stuck on. We took our minor troubles to Matron. Doctor Mack was jealous, overbearing. She disliked Matron, resentful that we felt the comfort of going to her. The Doctor pushed Matron back into her place. Matron was a fully trained nurse; Doctor was an intern, not as yet a complete doctor. One day Matron came into my room. I said, "Those open ventilators over my head create a perpetual draught, give me neuralgia. Could I have them closed?" Matron shut the ventilators. Doctor Mack strode into the room. "Since when has the Matron taken upon herself to close my patients' windows?" She snatched the cords, opened the windows with a bang! Matron quietly left the room —a big little lady.

"I will send you something for your neuralgia," said the big woman, who was small, and hurried down the hall. I heard her overtake Matron, heard Doctor's dictatorial bluster. Matron said never a word.

THE CIRCULAR PORCH

'Downs' kept their beds; 'Ups' walked in all weathers
and went to the dinner table; 'Semis' lay prone on
lounge chairs upon the Circular Porch, the better part of
most days.

The Circular Porch was a dreary place. The long
row of chairs was circled to fit its surroundings. They
had wavy seats to accommodate the reclining forms of
emaciated bodies. When the porch was empty of people
the chair seats looked like a heaving yellow sea that
almost made you feel seasick.

Round about noon the glass swing-doors were shoved
back by nurses so piled with books and pillows you might
have thought that they were laden moving-vans set on a
pair of human shoes. The nurse did not show at all
except her back, and to that clung her patient, tottery
and stumbling.

When the nurse had arranged all the rugs and pillows,
put the smelling bottles, the work bags and books all in
place, she helped the patient sit, then wrapped her up
like a mummy, and left her to doze, lie dead-still, or

31

Hokey with Emily in the Wheelbarrow

cough as she had a mind to. Only the worst cases were put on the Circular Porch. The better ones lay on the long row of chairs on the terrace.

There were few words spoken on the Circular Porch. It took all the strength of the poor beings there to breathe and cough. Click, click, click, the dreadful little blue-glass sputum bottles with silver tops that every bad patient must always have by him, opened and shut.

Nurses came often and looked through the glass doors. Doctor was frequently framed in the window of her office that overlooked the circled bunch of chairs.

When, after they had kept me in bed for three months, I was promoted to a 'Semi' and put for the first time onto the Circular Porch, I pleaded, "Not again, Hokey. Oh, put me *anywhere*, anywhere at all. Please, please let it not be the Circular Porch!" Hokey helped me to the lawn and pushed my chair under a bush. There was a bird's nest in the bush. Presently Jinny the donkey came dragging the mower back and forth over the lawn, James persuading Jinny's every reluctant step. Boots hurt Jinny's pride.

VISITORS

A NEW patient was put to bed, all his peculiarities noted, entered in the Doom Book. Had he one or two lungs? was he emaciated or naturally lean? cheerful dispositioned or grumpy? possessed of a poor appetite or just pernickety?

When this knowledge had been ascertained and recorded, Doctor McNair cast about for a couple of suitable visitors to cheer the newcomer. For me she selected Scrap.

Scrap opened my door inches—enough to squeeze her emaciated body through. It was that tiresome time after supper. You were too weary to do much and not yet ready for sleep. Scrap said,

"Doctor sent me. Do you mind?"

"I should say not! Won't you sit down?"

My one chair was full of books. "I'll sit up," said Scrap, and scrambled to the top of the high gilt radiator which, except for that brief half-hour night and morning, never radiated. It did serve, however, as an exalted seat for a visitor. There was no danger of him sitting too hot either.

Scrap was dark, thin, hungry-eyed.

"My name is Mrs. Scrapton. Everyone calls me Scrap."

"You don't look like a Mrs."

"I am though and have a baby six months old." At mention of her baby the hunger in her eyes turned ravenous. "I have been here two months, two months without my baby!"

I asked, "Are you ever warm? ever comfortable? ever happy here?"

Scrap's thin shoulders shrugged. "Not so bad once you get used to it, except—oh, I want my baby! Life here is like facing back, being a little girl again, told what to do, everything thought out for you, no responsibility, obey, drift, hope, that is all."

She drew a bit of woolly baby knitting from the pocket of the great-coat she wore. Her cold little blue hands began to work. That was the beginning of a friendship that lasted as long as Scrap lasted.

My other visitor was Miss Angelina Judd. Angelina had sped swiftly from 'Down' to 'Semi', from 'Semi' to 'Up', yet still her case was not fully diagnosed. She had hay fever in a superlative degree. I had thought that her persistent sneeze was a young rooster crowing about the grounds. Down in the hollows, up on the hills, it came with mechanical precision. How that cockerel does wander! was my thought. Angelina combatted her com-

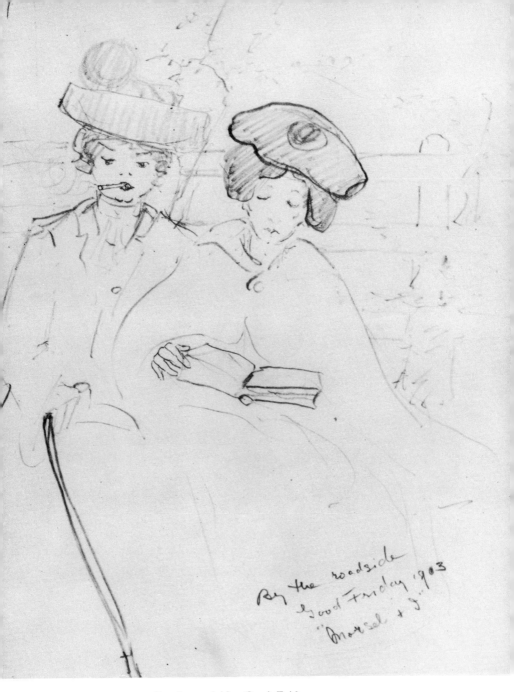

By the roadside, Good Friday 1903
"Morsel and I"

plaint by valiantly ignoring it. She sneezed right on.

Tap!—the opening of my door—a spasmodic bob. "A-choo! A-choo!" seven times repeated, then, "Doctor McNair sent me, and—" sneeze. "Do you like reading? What type? A-choo! A-choo!" She moved into the centre of the room. A question lurked in every sneeze, the violence of the spasm bumped her head on wall or furniture if she had not space.

Each week a great box of books came down from London addressed to Miss Angelina Judd. There was a book suitable for every patient; Angelina had previously probed every individual's taste. If a patient were unequal to reading, Angelina read to him. The sense was all sneezed out but Angelina kept right on. She had a little mouth and small pointed teeth that gleamed as she read. Her nostrils were as black as coal buckets, burnt with nitrate of silver for her hay fever.

Like a striking clock, or a cow with a bell, Angelina by her sneeze kept us informed of her exact whereabouts.

When a box of new books came, she piled them up and up on her chest till the topmost was wedged under her chin, then she started on her rounds. "A-choo!" The first sneeze almost strangled her because of the library; off flew the top book! That loosened the whole pile. "A-choo, bang! A-choo, bang!" all down the corridor. Angelina no sooner picked one up than she sneezed another off, but like the fine old battle-ship she was Angelina steamed straight ahead.

BIRDS FOR CANADA

MY lungs being healthy I was not of much interest to
Dr. Bottle. Once in a while I received an apathetic visit.
On one of these occasions she said, "There is a possi-
bility I may be going out to Canada; tell me about the
climate in the West. Western Canadian yourself aren't
you?" I told and Dr. Sally listened, her head a little on
one side, calculating the effect of such a climate on lungs.
At the end of my tellings I said, "England is a great dis-
appointment to me. I don't like it but in one thing it
does beat Canada."

"What is that?"

"Birds. In the West of Canada we have very few
birds—almost no songsters."

"Why do they not import some?"

"It has been tried—unsuccessfully. The birds died."

"What was wrong?"

"Adult trapped birds, most of them, died on the
voyage; the remainder, dazed and terrified, were loosed
immediately and were destroyed by birds of prey."

"Do you think it could be done successfully?"

"Yes, by hand-rearing the birds from the nest in England, shipping them to Canada, keeping them in large semi-free enclosures, till they were acclimatized and had raised young in the new country. Free the young when the band was strong. Loose them in open, settled country from which settlers had routed hawks and owls."

Dr. Bottle's head twisted a little more, her eyes popped.

"Go ahead," she said.

"You mean here? Raise the birds here!"

"Why not? Another month and there will be thrushes' and blackbirds' nests in every hedge, every bush."

That night I wrote to London for bird books. I learnt everything about thrushes and blackbirds; those were the songsters I wanted most. I waited breathlessly for spring.

The foolish birds could not bide for the trees to be leafed before they began their building boom. The hedge rows were so bare that the nests were in plain sight. Boys and cats took their toll. Parent birds screamed for an hour, then rushed to rebuild; nothing could stem the spring-tide of creative activity.

My books said, "Take the nest entire after the young are partly feathered, but before consciousness has come to their eyes; then, the old birds have ceased to brood and are tired of feeding."

Dr. Mack was generously sympathetic to my plan. She let me skip a rest period that I might make my first

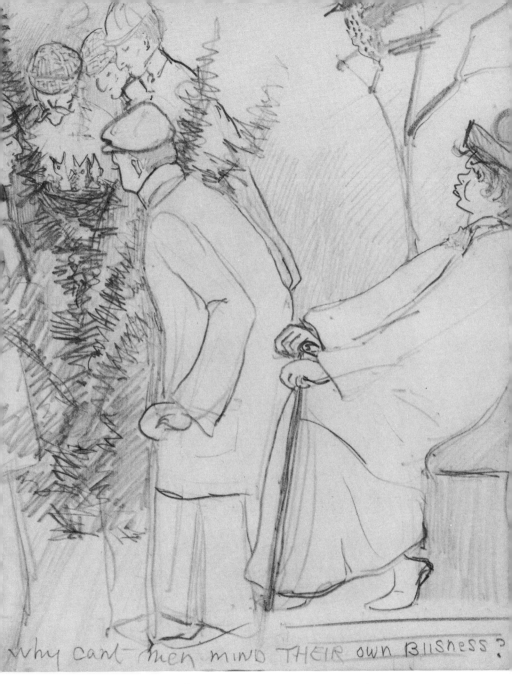

Why Can't Men Mind Their Own Business?

5 o'clock a.m.
Ap 15, 1903
Darn 'Em

theft at dusk. I put a cloth over the nest, loosed the hold of the twigs. The thrush family was mine! It was thrilling to hold the throbbing nest full of birdlings.

The nest was put in a little basket that stood on a tray by my bedside. As soon as it was light I began to feed the nestlings and did so at half-hour intervals till it was dark. In all I took six nests of thrushes, two of black-birds. The birds throve, rushing to maturity. Soon the sightless blue bulges opened, disclosing round black eyes. Nakedness was fully feathered. They stood upon their feet when they saw me, squawking, gaping over the side of the nest, demanding, confident, as sure of me as if I had been a beaked and feathered parent.

Dr. Mack named me Bird Mammy. Every Rest Hour she looked at them. To this drab place the birds brought interest and joy. Patients crowded hungrily around the new interest. Men took empty match-boxes on their walks and came back with pockets literally bulging with worms and beetles. Women took long-handled spoons and robbed ant hills of their eggs. "Great fun! Zips up the walks!" they said. One woman there was who stalked ahead muttering, "Disgusting!" The others enjoyed her fury for she was not a favourite.

Sick hands, thin and white, were always slipping offerings across my windowsill, offerings for the bird-lings. Brown hands of gardeners added wormy contri-butions. Mrs. Green, the cook, gave huge rhubarb leaves which we spread on the lawn; wetted, they yielded a

harvest of little white slugs coming from nowhere and making wonderful meals. The birds were the delight, the talk of the San. Everybody worked for them.

Hokey was splendid. Sometimes at post-time she came in dangling little bags from her finger tips. "Ugh! If I did not love you!" She dropped the sacks upon my table; they contained yellow meal worms from London pet shops.

"Hokey, you are an angel."

Ada the Quakeress was anything but an angel. She found my glass jar of meal worms and beetles behind the washroom boiler. The San rocked with her shrieks. There was cloth tied over the top and meal inside. I always forgot if the worms turned into beetles or the beetles turned into worms.

The birds outgrew their nests, their cages, my room. Then they were moved to a large cage out of doors.

If at any time I was unable to go to my birds, there was always some patient willing—glad to lend a hand. Common boredom, common interests, knit us tight. Shuttles we were, flying across the warp of San rules— empty shuttles to be sure, but maybe the San was weaving more pattern than we guessed.

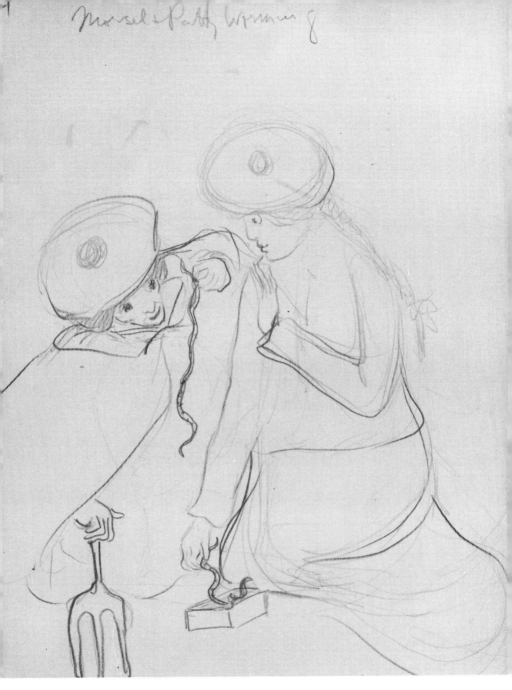

Morsel and Patty Worming

JENNY

"Go cheer the child in the next room, Mammy. Bad lung case—overwhelmingly homesick—name, Jenny."

I found a straight-haired little girl, a child of twelve—pointed chin, big eyes, flushed cheeks, hollows under their pink, eyes too bright, set deep.

"Hello! I'm your neighbour; Doctor said I could visit you. You are Jenny, aren't you?"

"Yes, are you the Bird Lady?"

"The baby thrushes and blackbirds are mine."

"I have never seen a baby bird. I come from London. Do your little birds keep you from aching for home?"

"Well, I live in Canada. That is a long, long ache, but the birds do help a lot, Jenny."

"I'm glad you've come. Have you been in the San long?"

"Four months."

"Four months! And I only, only two weeks. My little brother and I are orphans. We live with our Aunt in London. She is very rich. She says it is scandalous the price the San charges to keep me here, but she is willing

because she is dreadfully afraid of catching my lungs. She won't let me kiss her, or kiss my brother. It's dreadful living without kisses. Tell me about your birds. Birds are the nicest things in Sunhill, don't you think?"

"The very nicest, Jenny."

"Let's be friends. Enormous friends!"

"All right. I tell you what; our beds are right against each other, just the wall between. We'll invent tap-talk, shall we?"

Jenny frowned, "Shout back and forth? We daren't. Doctor'd hear."

"We wouldn't shout things; we'd say things by tapping on the wall—tap, tap, 'Good morning', tap, tap, tap, 'I'm fine'."

"That will be fun," said Jenny. "What else shall we say?"

"Clean plates are very important. Four taps: 'Have you made a clean plate?' Smart tap: 'Yes', dull bang with the palm, 'No!' "

The code worked splendidly.

After supper one night in answer to my four taps a monstrous slap from Jenny's palm.

I went to her. She pulled the sheet over her head to hide red eyes. Before the child was a plate piled with sliced raw carrot.

"Hello! What's that?"

"A beastly new idea of Dr. Bottle's—raw carrot!"

"She has got you mixed with Jinny the donkey!"

49

Between giggles and "he-haws" the carrots began to go down. We were making fine fun and did not hear Dr. Mack till she was in the room. Over her glasses and under her glasses the Doctor's eyes called me "Fool". In her most awful tone she said, "Hush!"

"Sorry, Doctor. I was trying to help Jenny's carrots down."

"Temperatures, Mammy! Temperatures! Must not excite the child. Neither laughing nor crying to excess is permissible here!"

ORCHID

HOKEY stood at the foot of my bed, holding a single flower up for my inspection, fully conscious that this was some splendid thing she had to offer. It was an uncanny flower with a pouchy body as big as a pigeon's egg. It was yellow, splotched with brown-red. At the top it had a five-point purple crown. Live little veins of red laced its pouchy body. Not only was it unusual, there was mystery in its dull glowing, too, some queerness almost sinister, very, very un-English.

"Hokey! What? Where?"

"Orchid—London—a box of flowers sent to Mrs. Spoffard by an old admirer. Came from a Regent Street swell florist. She divided the flowers among the patients. This was the only orchid. She said the splotches on the body made her think of your thrushes. She wished you to have the orchid."

"How kind! I don't even know her."

"She is always fussing round your bird-cage," said Hokey. "Loves them and through your birds she loves you. Your birds make a lot of friends, don't they?"

51

"Patients here *are* generous, Hokey, always sharing up what they get."

Hokey nodded.

I wrote a polite note of thanks for Mrs. Spoffard. We put the orchid in a vase by itself. In my room I had other flowers but this one stood aloof like a stranger in a crowd whose language he does not understand. It grew a little larger; its pouch bulged pouchier; it poised its crown a little more erect. When it was mature, entirely complete, it stayed so, not altering, not fading, week after week till six were past. A tremendously dignified, regal bloom. Everyone who looked at it seemed impelled to reverence, as though the orchid was a little more than flower.

In the dark one night the orchid abruptly died. Died completely as it had lived. Died like the finish of a bird's song. In the morning it was shrivelled to a wisp. Hokey took it away. There was a blank, a forlorn miss on my bedside table.

Suddenly I imagined that I understood what had been the link between that strange flower and me. Both of us were thoroughly un-English.

THE JOKER

ANGELINA JUDD was not the only patient fired with desire to cheer her fellows. There was Susie Spinner, a sparrow-like creature with a giggle, and nostrils that bored into her face like a pair of keyholes. You saw these black holes before you saw Susie. All the rest of her was colourless— neutral drab hair, grey skin peppered with pale freckles, toneless giggles in bunches. After each bunch of giggles at one of her own jokes, a great sigh burst through the keyholes and Susie's flat forehead churned into wrinkles. Susie was enthusiastic over her own jokes and sprang one after another like waves splashing on a beach. Each joke had a bridesmaid, or rather four bridesmaids, when everything Susieish happened all over again, giggle, sigh, wrinkle, joke!

Susie Spinner was not T.B. She was a friend of Dr. Bottle's and came to the San for week-end jaunts because she loved the place. She ran an office in London, also an aged mother. She was not young herself. These little rests at the San kept her going; she loved to float on the dead sea of San life, doing as she was told, stretched

53

inert on a lounge chair on the terrace, speculating as to each patient's chances, telling Susie Spinner jokes.

"Hokey, I prefer dismal patients to jokers, if patients there must be."

Hokey said, "Miss Spinner wants to meet you."

"A want not reciprocated."

"Don't be a grump." She set our chairs side by side on the terrace.

Close-up, the gymnastics of Susie's features were more irritating than I had suspected.

"I have heard about your birds for Canada. (Giggle!) Splendid idea. (Giggle, giggle!) I adore birds, don't you? But, of course, or you'd never—". (Giggle, giggle, giggle.)

Rest bell. I got up. The bell's clanking vibrations drowned the end of Susie's giggle. I left her doing all the things that completed the sequence over again.

"Hokey, I hate you."

"Why now specially?"

"Susie Spinner'll brood my birdlings day and night. My life will be addled with Susieisms."

"Miss Spinner is a nice woman, always comes down from London with a headful of jokes to make everyone laugh—everyone but old grumpies like you." She shook her head, gave my pillow the punch I deserved.

"All right, Hoke, long live the giggles! I do thirst for some mourning-doves, some weeping-willows round here; everything is so forcedly gay."

spilled the ink upon my bed
word of rage dear Hokey said.
...ked an orange o'er the sheet
...ursted still was Hokey sweet;
bottle leaked—The sheets got wet,
... she remained serene as yet,
door latch broke, it would not shut,
... never even said 'tut! tut!'
...wind blew through so chill & raw
blew my vases to the floor,
...d soaked my things in every drawer
...cid was Hokey as before,
...k a family of birds
...id 'Now surely there'll be words'
...y made a noise, they scattered food,
...y were a most unruly brood,
...Hokey never got irate
...r brought them food upon a plate
...d stood & watched them as they ate
...d hoped they would not suffocate
...t one restriction she imposed
...at I should keep my worm box closed
...! Woe! alas! like Mother Eve,
...r one command I do receive
...d yet like Eve—I disobey—
...a little worm creeps out to play—
...ear a screech, I give a start;
...Hokey clutch her throbbing heart
...r she thinks one little word.
...gentle Heart with grief is stirred
...! writhing worm, not you alone
...th caused Hokeys screech & groan
...s not alone she loatheth thee
...e disappointed is with me.

...at I should let you crawl abroad
...nowing how much you are abhorred.

Hokey's Poem

"That's morbid," scolded Hokey.

"It is not morbid. Listen! Once, out in Canada, I stayed with some Indians, lived right in their own home. Primitive it was but wise. When they were hungry, they ate—happy, they sang—sleepy, they slept—when they wanted to cry, they cried torrents, vast oceans of tears that washed their miseries completely away, left their faces clear as morning."

"Very sloppy—very uncontrolled," said Hokey.

"ME"

I was not always polite, not always biddable. The monotony bored me. I despised the everlasting red tape, the sheep-like stupidity. What one did, all did, and because they always had done such and such it meant that they always must.

Doctor McNair was a pretty good sort, if a bit pompous to her underlings, and a bit servile to her superior. Doctor Sally Bottle, I frankly despised for a toady. She licked the boots of the wealthy and fairly ate the feet off a title. She was terribly almighty over week-ends in the San.

I don't believe Doctor Sally saw people when she looked in their faces. She saw and calculated the value of the lungs in their chest.

I got on with most of the nurses. I loved Hokey and Matron Lovat.

Serious work had been put out of my life but I used to make caricatures and silly rhymes about the patients and staff, at which they used to laugh immoderately.

Because of those laughs they forgave a lot of my short-comings.

Time ambled by, days alike as peas in a pod—sleeping, eating, resting. They kept me in bed for three months. Then I was a 'Semi' but I never was a complete 'Up'. I only went to table for the noon dinner and walked little.

Lament of the Polar Bear

I perished in the London Zoo
Because it was so hot
I used to lie and bake and bask
And murmur at my lot
Oh, had I been to Nayland sent,
I would not now be dead
But feeling quite at home and cool
Instead.

58

Lament of the Polar Bear

I perished in the London Zoo
Because it was so hot.
I used to lie & Bake & Bask
And murmur at my lot.
Oh had I been to Nayland sent
I would not now [be] dead.
But feeling quite at home & cool
instead.

SOLDIERS

WHEN a downer was very down, a nurse would come to my door and say, "Lend the soldiers?"

The soldiers were my bullfinches. When the thrushes were out of hand, I stole and reared two nests of black-bonneted, rose-breasted, chesty bullfinches. Always singing, always dancing, they went their round of cheer. Very sick patients would lie and watch them by the hour. Chortling on the perch, squabbling for place and importance, the supreme glory was to be wedged in between two cosy brothers. For this they fought.

Jenny, the Cranleigh Boy, John Withers, all the 'Downs' loved my soldiers.

To John Withers "them pioneers", as he called the thrushes for Canada, were even dearer. As long as his weary body could drag, Hokey put his chair in the sheltered corner by the thrushes' cage and took him there that he might enjoy their daily bath. John laughed till the tears ran down his cheeks, tears and the splashes from the birds' bath. Again and again I filled the big dish. After the bath there were shakings and preenings. It was

61

the delight of John's day. Hokey led him back to his room. There was a hard spell of coughing after the exertion, but John went again next day to watch the birds bathe.

As he lay back on his pillows afterwards, with closed eyes, Hokey would often think John slept, till,

"Hark, Nurse!" John's eyes would open to follow an ascending speck out over the fields, watch till the clouds took the lark. Only the golden pebbles of his song scattered back to earth.

" 'Ear 'im, 'ear 'im, Nurse! Carted 'is music clear to 'evin, 'e 'as." John was a Londoner. He had been with his master through the Boer War, contracted T.B. His master, an Honourable, brought him home, placed him in the San. He said, "Give my John everything, anything. I can never repay John's faithfulness." His master's visits, the birds of Sunhill were all John wanted, dear, gentle old man. Doctors and nurses loved him.

John's cough went from the east wing. Hokey tried to force cheerfulness, settling me for the night. "Books, singing-soldiers, have I done everything?" she prattled, forcing gaiety.

"Hokey, don't sham! Was it the larks or the nightingales that sang John Withers into Heaven?"

Hokey choked. "Dear old man . . . a lark going up, up, up, was the last thing he noticed." Doctor's step! Hokey pulled her face straight, flew from my room.

FOOD

Forty and more fickle appetites strolled into the San dining-room, unenthusiastically took their places at table. A big part of the T.B. treatment was eating. Eating was compulsory. If patients refused to eat, the San refused to keep them as patients. Doctor McNair and Matron stood at a side table and served. Were Doctor Bottle present, she dictated the helpings, cruel mountains of meat, vegetables and pudding helpings that would stagger the appetite of healthy men and women, and were positively loathsome to invalids. The maids brought the hateful plates and slapped them down before each patient. You felt "pull-together" and "nausea" struggle in disgust and revolt as each patient surveyed her pile. When all were served Doctor and Matron took their places, one at either end of the long table, and started animated conversation. One by one the patients picked up their knives and forks and began to attack the food. It was bravely done.

There was an oldish school-master who had been attacked by T.B., a man accustomed to exact, not yield

obedience. I saw this man scowl at his helping of spinach with a little boy's fury; I saw little boy's tears come into his eyes, tumble down his cheeks, hide their shame in his man's beard. He beckoned a maid and whispered. In turn she whispered in the Doctor's ear.

Clear and stern, Doctor McNair enunciated so that everyone could hear. "If Mr. Dane cannot eat spinach, substitute a double helping of carrot." The oldish man smiled his thanks. "Sorry, Doctor, never could even as a boy."

His neighbour, a florid woman nodded; "I entertain the same attitude towards carrots, Mr. Dane."

Munch, munch, munch. Miss Dobbin, the woman opposite, chewed doggedly, determined to see the treatment through. She scorned the whimperings of the little neurotic on her left, the yawning envelope pinched between the knees of the hypocrite Marmaduke Jepson on her right. Between chews Miss Dobbin could not resist peeping to see if Marmaduke's flip had landed true. His policy was to engage Doctor in an eye-to-eye conversation while he flipped. Great portions of his food flew into the waiting envelope; without so much as a glance his aim was accurate. Doctor was always holding Jepson up as an example to the rest, too, because of the speed with which he made clean his plate.

"Not that it has made much impression on your bones yet, Mr. Jepson. It will tho'. Patience, courage!"

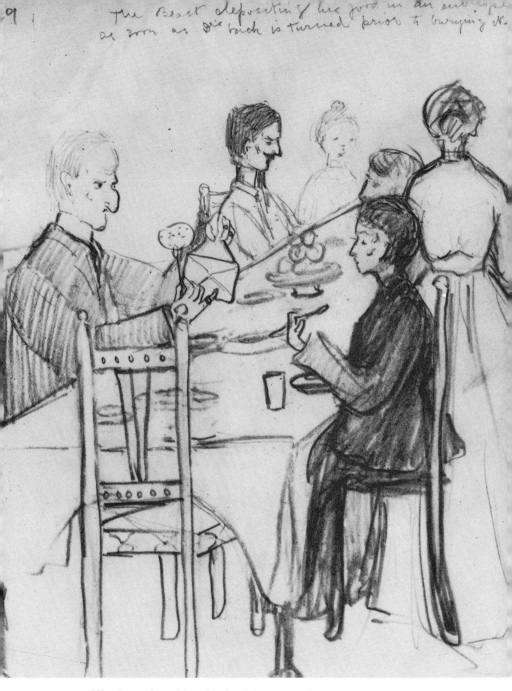

The beast depositing his food in an envelope as soon as Doctor's back is turned prior to burying it.

"Thank you, Doctor, thank you, I try to be a credit to the San."

"Credit! Ugh!" grunted Dobbin, as Jepson's baked potato landed in the envelope.

Miss Bret laid down her knife and fork, closed her eyes; just for one second she must shut out the sight of food. She heard Doctor say:

"If this weather holds we shall have strawberries next week." Food, food, always food!

A maid bent close, "Are you going to finish, Miss Bret?"

A silent head-shake. The maid removed the meat plate, substituted a generous cut of roly-poly pudding oozing jam. The struggle began all over again. Miss Bret knew that the plate of meat and vegetables would be taken straight to her room and must be eaten some time before supper. The jam roly-poly would join it there unless—. She severed six jammy little pieces, bolted them one after another like pills, controlling herself heroically against being sick.

"Suppose you can't; suppose you won't?" I once asked a patient.

"At bedtime it will be removed and a huge bowl of Benger's gruel substituted for it."

"Suppose you refuse that too?"

The patient rolled her eyes round in her head like an owl. "You couldn't. Your people would be asked to

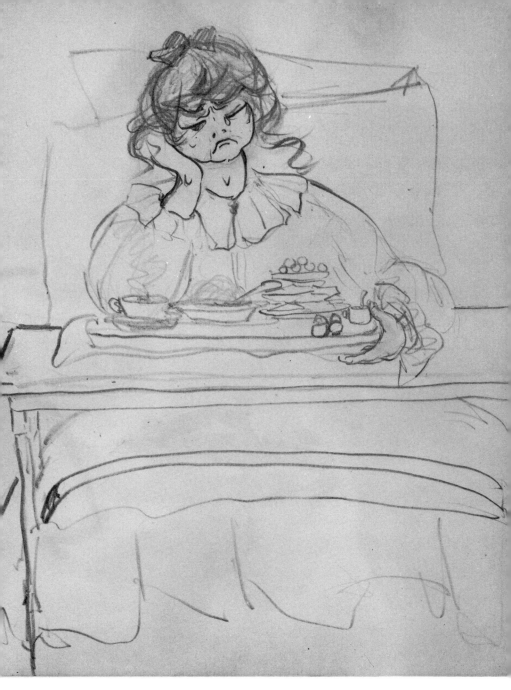

I Cannot Eat

remove you, not giving the treatment a chance! Or Doctor Bottle's reputation, either!"

"Drat Doctor Bottle and her reputation!"

"Quite so, but your people? They have made sacrifices. You can't let them down, and there is always the chance you might infect someone at home, besides making life uncomfortable for them—open windows, special food!"

Every Saturday Mrs. Cranleigh dined with us. She came from a distance to visit her son and her daughter. Both were patients in the San. The son was bad, the daughter only slightly infected. Mrs. Cranleigh had already lost two children with T.B. She was taking no chances with Kate.

In spite of her children that were dead and her children that were sick Mrs. Cranleigh was hideously buoyant and optimistic. The staff alluded to her as "that brave soul!" They said she was a "moral uplift" to the San. She paraded her fortitude to such an extent and hoisted her buoyancy to such a pinnacle it made everyone else slump.

Mrs. Cranleigh's favourite food was cabbage. The San garden excelled in great crisp monsters; all of the cabbage tribe were represented. Miss Brown, the gardener, Doctor Bottle who was always present at Saturday's dinner, and Mrs. Cranleigh lapped up the flabby green with relish, discoursing all through the meal on

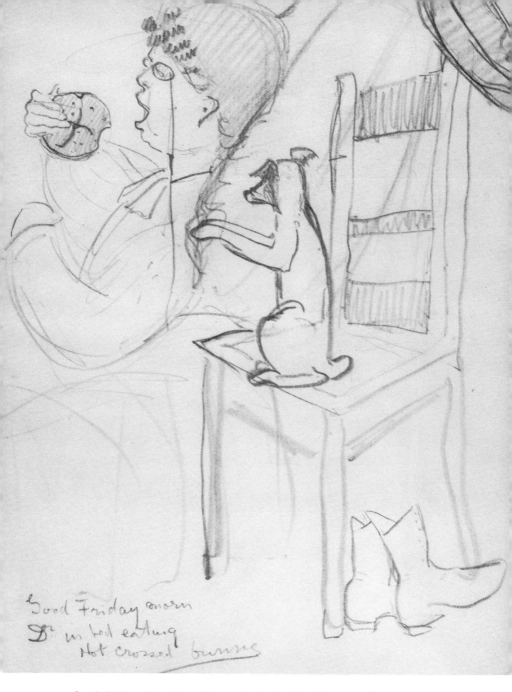

Good Friday Morning. Doctor in bed eating hot cross buns.

the merits of the different species. Mrs. Cranleigh kept up a running undertone, "Beautiful cabbage! Beautiful cabbage!" The patients nicknamed her, 'Beautiful Cabbage'. Then Doctor Bottle would insist that everyone must have a second helping. She inflated over the San's beautiful cabbage, till she nearly burst. It was a privilege to be able to eat home-grown cabbage such as this! "Beautiful cabbage. Beautiful cabbage!" echoed Mrs. Cranleigh till we hated cabbage of every kind, human or vegetable.

Marmaduke Jepson sat near the dining-room door; he always sprang from his seat to open it for Doctor McNair. When she swept from the head of the table down the long dining-hall, Dr. McNair, what with her great height, the flowing dinner gowns she always effected, and all the dignity she had at her command, looked like a ship in full sail advancing.

Marmaduke sprang as usual, took out a perfumed florid handkerchief with a flourish, fluttered it to undo

Some eat, some won't,
Some try, some don't,
Some weep, some cough,
Some jeer, some scoff,
Some gasp, some scowl,
Some grunt, some growl,
And everyone puts on a woeful face
And ah! dear me! I fear that none say grace.

Some eat, some won't
Some try, some don't
Some weep, some cough
Some jeer, some scoff
Some gasp, some scowl
Some grunt, some growl
And every one puts on a woeful face
And oh! dear me! I fear that none say grace

its folds, pulled out more than the handkerchief. Plop! Right in front of Doctor's feet slapped the pancake Marmaduke should have eaten at table. Doctor had to detour to avoid treading on it. Marmaduke swooped— too late! The Doctor swept by with a pointed, "See you at Rest Hour, Mr. Jepson."

"Good Lord, Dane!" Marmaduke called to the spinach objector, "did you see her face? Quick, let's make a prompt get-away for our walk." They took hats and sticks from the hall-rack and bolted.

"One minute, Dane."

Jepson took his cane and bored a hole in the soil of the garden, widening and deepening the bore to accommodate the pancake and an envelope, very fat. Carefully he covered them with earth.

The lady gardeners could have told of a vast undercrop of envelopes addressed to Marmaduke Jepson, Esq. in the garden. They did not. Marmaduke always had a smile for them, always a compliment.

THE GARDEN

THE garden lay in a shallow valley tucked between the hill on which stood the San and a moundy hillock where sheep grazed. When the wind blew from the west, you smelled the sheep and heard their mock-meek bleats.

The little valley caught and held all the sunshine. Great cabbages, beets and onions absorbed it. There were few flower-beds in the San garden; its purpose was to provide fruit and vegetables for San patients.

In the centre of the garden was a huge evil-smelling tank into which drained the suds and dish-water of the laundry and kitchen; it was used for irrigating the garden. Dr. Bottle's pride was that there should be no waste. Economy, efficiency ruled Sunhill.

A lady gardener, by name Miss Brown, queened it over the garden. Miss Brown was sister to my Hokey, but Miss Brown the gardener and Miss Brown the nurse were not alike. There was also, in the San garden, an understudy, one Miss Lavinia Mole. The two garden ladies were sun and soil-parched, hair, skin, work gloves, shoes, all yellowish clay-colour; this brace of Eves toiled

and sweated among the roots and fruits of Sunhill.

Dr. Bottle loved the garden. Every Saturday her squat hatless figure ran down and puffed'up the hill, to examine, to dictate, while the not-so-keen Dr. Mack plodded after. Having no voice and little heart for agricultural pursuits, she dragged wherever her chief dictated.

In the garden Dr. Bottle met her match. The high-bridged hooky-nose that pinned hardness down onto Miss Brown's face did not audibly sniff at Dr. Bottle's agricultural ignorance; Miss Brown simply brushed it aside and took her own way. Smiles seldom waded among the leathery wrinkles of her face. She was a good gardener, not flowery-sentimental, but produce-proud. An occasional posy graced the San's public rooms. The dinner-table always groaned under her vegetables.

It was strawberry time. The heavily netted vines were loaded. Scarlet lusciousness peeked between the leaves, making your mouth water.

"Oh, Miss Brown, what a monster! What a perfectly splendid berry; most as big as a pumpkin!" My foot struck against flesh—dead flesh—irresponsive, sickening.

A pile of little bodies, glossy black or mottled brown, having limp spread wings—lolling heads—music stilled in twisted throats—dead! Thrushes and blackbirds.

"Oh, oh!" I cried. Miss Brown shrugged, laughed through her high-bridged nose. "Thieves netted in my berry patch."

Horrible, horrible garden! Smelly tank, clay women,

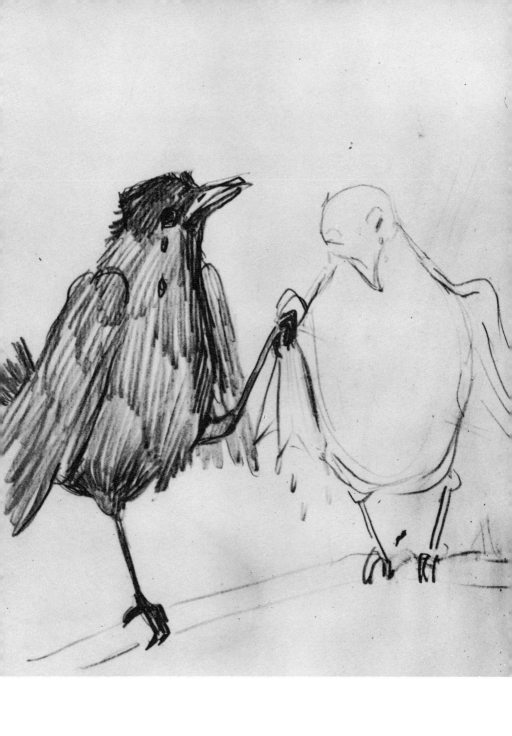

dead birds, naked fledglings waiting, waiting in nearby nests, holding up scrawny necks till they could no longer support the gaping mouths, heads flopped. Starved bird-lings! Tomorrow morning there would be another pile, every morning more! Miss Brown would fertilize her garden with their beautiful bodies! Earthworms would writhe around throats lately filled with song. I hurried from the garden, left it to the cabbages and the clay women.

THE FRENCH BABY

DR. BOTTLE bustled down from London. Nothing so delighted her as to get some patient a little out of the ordinary.

"Youngest yet!" she purred, leading the way to the largest, most expensive room in the San. A young couple followed carrying a baby, a pitiful little wreck. Both parents cried aloud as they came. This was their firstborn. "Pierre, Pierre, Petit Pierre!" they moaned.

A little white cot had been put in the centre of the big room. The weeping parents drew chairs, one on either side of the cot. The cot was sometimes put on the terrace, then the French couple took their chairs and sat holding hands across the canopy of the baby's cot. No matter where the nurses put Baby Pierre, papa and mama picked up their chairs, followed. They wept and kissed; a hand of each was locked in that of the other.

If Nurse took the baby away to tend it, the couple walked up and down the terrace kissing, comforting. Their foreignness seemed to enclose them in complete privacy. We did not exist, nothing in the universe existed

except themselves and their great sorrow. Cold English allowed their tears to congeal, ossify under the skin of their faces. The French said, "Stupid fools. We French cry." They cried hard and watched their child fade.

The baby was too weak to wail any more. The father's and mother's hands froze in each other's grip. Everyone tiptoed past the room where little Pierre was; we knew the baby was dying; it was not kept secret like mature death. The whole San cried for Baby Pierre, boldly, unashamed.

The door of the room stood wide; the little cot was gone. Gone too were the French couple. A tiny white marble cross stood among the more mature tombstones of Sunhill Cemetery.

MRS. VINEY

A GAUNT creature, wobbling between dignity and weakness, made her first appearance on the terrace. She chose the lounge chair that was between one occupied by a woman with transparent ringed hands and another containing an abnormally clerical parson, with a collar like a retaining wall.

When the new patient was tucked, pillowed, hotwater-bottled and smelling-salted, she turned to the clergyman.

"My first time up."

Silence.

"I am free of temperature and cough!"

Still silence.

She tilted the pink tam a little more, sparkled her eyes, smiled at the parson.

He sank down into the protective starched circle of collar. A pair of pale hands raised a drab-bound volume up, up, till his face was gone.

"Nurse! Nurse Maggie! Face me the other way."

On readjustment she enquired of Rings, "Are you

normal?" Rings glowered. "Temperature, of course. This wild life is said to be healing. Detestably monotonous, I must say."

Rings bowed coldly.

The newcomer shook out her knitting; her needles clicked angrily.

Up piped a childish treble, "Mrs.—, Mrs. New Lady. Perhaps no one has told you; it's the San way not to mention temperature or coughs. Those things are only Doctor's business here. We are not allowed to talk sickness."

"And who may you be, Miss Pert?"

"I'm Jenny. What is your name, please?"

"Mrs. Viney. Pray, Jenny, what *are* we permitted to talk about in this place where nothing ever happens?"

Jenny looked across the lawn. "Well, there's birds, Mrs. Viney."

"Birds and to spare making bedlam of day and night!"

A bell clanged; silence fell upon the terrace; every soul either there or in his room was sucking a thermometer and quiet. It was the noon Rest Hour.

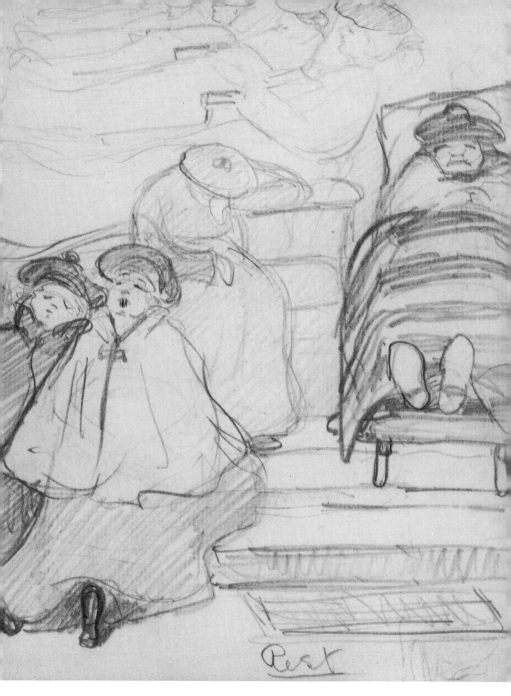

Rest

MRS. DOWNIE

I DON'T know how I got to know Mrs. Downie because she was exclusive. "Come to tea and bring your doings," she invited. For the moment my "doings" were effigies of the two Doctors. The 'Ups' bought wooden dolls for me at the village shop in Stillfield. I adapted and costumed them to mimic characters.

Tea was set in the big bay-window of Mrs. Downie's room. Her fine room at the end of the east wing overlooked not only the terrace but the whole countryside as well.

Mrs. Downie did not walk with 'Ups'. She did not lie on the porch with 'Semis'. She was not a 'Down'. She reclined on a lounge chair in the window of her big room, surrounded by the newest books in clean jackets and the choicest flowers from London shops. Her meals were served to her there.

She lay now watching with amused interest my effigies being stitched into life. I was working on Dr. McNair's undies. Mrs. Downie asked, "What do the Doctors say to their effigies?"

"Just laugh. I had trouble in getting Dr. Mack's legs long enough and the right twist on Dr. Sally's neck; you know her listening kink? I had to borrow Cook's meat-saw, saw through the neck and glue it back twisted. I had to give Dr. Mack's legs an extra joint."

On the terrace below, heavy tea cups clanked, listless hands busied themselves over bits of needlework or knitting; round bright tams bobbed beneath us like toy balloons, floating singly, bunching for gossip. Jenny's merry laugh floated up, other laughs, some infinitesimal joke. "Hush! . . . Doctor." "Probably Dr. Mack is framed in her window!" I told Mrs. Downie.

Miss Brown and Lavinia Mole humping up the garden hill, tired, sweaty, wanting their tea. "A-choo! A-choo!" Angelina Judd somewhere behind the rise. Two men mounting the terrace steps; one limps, the other has a scar across his cheek.

"Out in Africa—," says Limp. "I remember," replies Scar.

The two men take their tea standing on the terrace, sipping slowly. A child's sweater is held up for inspection, "Are those sleeves a pair?"

"True as scales." "Nice colour, how many stitches?"

The bell, bobbing tams, closing doors, silence. Mrs. Downie turned from the window. "They *are* brave. I am a coward. Just seeing them is almost more than I can bear. Dr. Bottle advised. Tom begged." She shrugged.

Dutch Boy

"I stipulated that I should not eat or mix with them. Tom and I waited seven years to marry. They said I had quite outgrown the tendency. T.B. is hideous the way it lurks and pounces, long after you think you're safe."

Rest bell. Mrs. Downie settled into her lounge chair. I packed the Doctors' effigies into their box, went to my room.

Mrs. Downie stayed in the San a few months, then she went with her husband to Sicily. From there she sent me what must have been glorious flowers. Alas, when I opened the box every flower was dead. She said she was sending me a box of flowers every week. I wrote, "Don't. They come dead." The San people said I was foolish, I should have let Mrs. Downie have the pleasure of thinking she had given me that joy. I felt that would be shamming, dishonest. I appreciated her thought and told her so. In the San they said, "Mrs. Downie has money. She would not miss their price. It is better to tell a minor fib than to disappoint." They accused me of striding rough-shod over people's more delicate feelings.

SONG

A NURSE from London, doing 'Special', was singing. The piano was at the end of the long dining-hall. 'Ups' were grouped around it listening. The nurse's voice was neither good nor bad. The music carried across the court to the patients' rooms under the wings. All sounds were common property at the San.

Men and women patients lay in bed, some critical, others soothed. Nurses paused in corridors, maids stood just inside the dining-room swing doors. A hefty foot swung the door from the kitchen, scattering the maids. The door stayed open. Mrs. Green's plump elbow kept it so. She stood lapping up the music. Soon she was weeping over the mawkish sentiment that sent nurses about their business, patients to their rooms.

I looked in to see Jenny. "Hear the music, Jenny?"

"Uh, huh."

"Enjoy it?"

"Not much. Hark! He does it every night just at this time. I have been so afraid her noise would drown him."

Across the night, across the garden, into Jenny's room swept the serene melody of a nightingale. Again and again it came. Jenny and I held our breath. It was the nesting season. All night the male sat near, singing to his brooding mate. It is the nightingale way.

In a room down the corridor Mrs. Viney sprang from her bed. "Confound the brute! Just as I was getting off!" Bang! went the smelling-bottle onto the floor, as she reached across the table for cotton wool. She jabbed a wad into each ear and slapped her head down onto the pillow.

Mrs. Viney appealed to the Parson next day. The Parson was reclining on the terrace. Nurse Maggie came staggering under a load of invalid accessories. Everybody knew to whom they belonged, before he saw the peevish face behind.

Mrs. Viney sank into the chair. "Have I everything, Nurse? Book, glasses, smelling-bottle, handkerchief. Oh! the thermometer, hand me the thermometer. I shall take my Rest Hour here." She languished among her pillows with closed eyes, long enough to impress. Then she "unfurled", (she had stated on the terrace that people *should* unfurl their lids like petals, not pop them like ginger-beer corks).

The Parson had just found his place. He plunged into his book the moment Mrs. Viney came. She generally sought his proximity. Today she leaned across, laid an

appealing hand on his rug, "Mr. . . . Mr. . . . ?"

"The Rev. Brocklebee, if you please."

"How stupid of me! Brocklebug of course." For sweetness her smile would have shamed honey. "Do you not think, Mr. Brocklebug, the price we pay and all, something should be done? Why should our rest be disturbed by vermin? You, a clergyman, a public speaker, could you not voice our opinion publicly?"

"Do you refer to mice? I have experienced no trouble," said the Parson stiffly. "Our rooms are open; creatures come in naturally; field mice are quite harmless."

Mrs. Viney shouted, "Nightingales, Sir! Who can sleep through their horrible din? Something *must* be done! Invalids waked! I declare. Only poets and fools rave about the nightingale. I *had hoped*, . . . being a public speaker . . . " She gave the Parson a saccharine smile.

Reverend Brocklebee's heavy face lifted from his book. "I take great delight in the nightingale's song, pray excuse!" He lifted his book.

Upright in her chair sprang Jenny, eyes flaming, cheeks scarlet. "How can you say those things? The birds making night hideous! Calling them vermin! Oh, Mrs. Viney!"

"Don't excite yourself, Jenny child. There! I would not wonder if you have put your temperature up. All for nothing! Silly Jenny, very, very silly, little girl."

LEGITIMATE PREY

THE laws of Sunhill Sanatorium were primarily made for the T.B.'s. Those patients not T.B. were more or less free-lances. We were therefore pounced upon by T.B. patients as legitimate prey to question for information regarding the "how bad state" of new patients. I never walked with the 'Ups'; otherwise I would have been asked about everybody and myself too. I heard that during the long slow walks of the 'Ups' I was the subject of a good deal of speculation. "No cough, no food restrictions, no temperature." Yet, here I remained in the Sanatorium month after month. Did anyone know what *was* the matter? "Heart perhaps?" "No, I have an Aunt with heart, etc." "Liver?" "In that case she would be sallow. I once had a friend—" "You don't think it can be mental?" "Mental nothing! Her tongue is sharp enough to mow the lawn." The Gossips strolled along. The discussion jogged to the time of their slow feet and got them nowhere. It was young Jenny who used to tell me of these wonderings at my expense. They knew the child was dear to me and I to her, but Jenny

95

was close-lipped. When they put their questions to her direct, she replied, "I don't know. I only know I love her. The San says we are not to talk disease." The child was very loyal to the San and to me.

The favourite walk of the 'Ups' was to Stillfield village. The village shop sold peppermint bull's-eyes, soap, stamps, and cigarettes. The proprietor, Mrs. Stocking, waited on San patients grudgingly; got them out of her shop as soon as possible. "T.B. bug-carriers" the village folk called San patients. They were angry when the Sanatorium was put in the district, although the San brought trade to the village and did not lie close to it. If village folk met patients on the roads they crossed and turned their faces away.

The San bus rattled through the village at train-time, picked up patients and mail and rattled home again, disturbing nothing but the dust. Matron sorted the mail and set the letters climbing the wire rack in her office. The 'Ups' waited, watching, apparently indifferent. They took their letter from the rack casually. In the corridor they hugged the envelope close, hurried to their room, laid it on the bedside table till Dr. McNair's visit was over. (Letters reddened one's nose and eyes most embarrassingly; being sloppy was such bad form.) You'd got to stay here till Dr. Sally Bottle released you. Cry-babying only smashed your morale, made the powers that ruled angry.

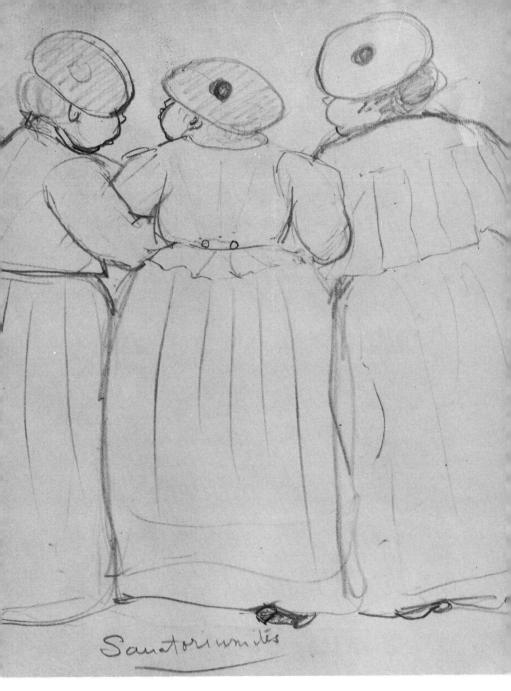

Sanatoriumites

A RABBIT WARREN AND A PIGGERY

"It's a bad, mad, crazily brambled snarly place riddled with rabbit holes; it's a bedlam of bird song. Nobody goes there; I just came upon it by chance. Here! I picked this posy for you there—all wild."

"I *must* see this place, Scrap, is it far?"

"Too far for you."

"Tell me the way."

Scrap drew a plan on my bed-quilt. Just in from her morning walk she had dropped in to tell me about this rabbit warren she had discovered, and to bring me the bunch of wild flowers.

"There's the Rest Hour bell!" Scrap put the flowers into my tooth-mug and went to her own room.

My walks were not set by the Doctors like those of the T.B. patients. I was free to walk where I would, providing it was not too far, and I did not overtire.

Immediately after our noon dinner I slipped out the side door without anyone seeing, past my birds' cage, skirted the San's big field, crossed the highway, found the lane that dwindled into a narrow foot-path and ended

in the Warren. It was indeed a wilderness! Tired I flung my body down upon the hot earth and shut my eyes, leaving free my other senses—feeling, smelling, hearing.

Brambles clutched and wove themselves about everything. Under the tangle of gorse and broom bushes gaped the cool mouths of rabbit holes; deep in them rabbits were sleeping, waiting for the cool of evening to release the kick in their long hind legs. Like the rabbits I, too, was soon fast, fast asleep.

Little feet scuttering across my body woke me! Rabbits bobbed everywhere. The sunny buzz of insects had stopped. Shadows were long, scents and bird song evening-sweet.

The five o'clock rest-bell would have gone long ago; deliberately I rolled over. The Doctors had told me it was better I should be late than hurry. I did not want more sleep. I wanted just to take all this in a little longer. I had not known you could find such wildness in England. This place seemed so beautifully mine— mine, and the birds' and rabbits'.

I walked very slowly back to the San. The supper-bell rang as I was going up the drive. I met Doctor McNair in the hall; she looked reproach. "We were beginning to wonder, Mammy."

"Sorry, Doctor, I fell asleep in the Rabbit Warren."

She shook her head. "At least you were resting. I

will see you after supper."

She came after the meal, helped herself to a cigarette. "Mammy, how far is this Rabbit Warren?"

Was she going to forbid my going again? I dawdled through my telling of how delicious it was, postponing the evil moment. Instead of forbidding me as I expected, Doctor said, "Take me there, Mammy." If once Doctor saw it she would surely understand. That week we went to the Warren, Doctor and I. It was just as fine a day as before. We crossed the field, the highway, the lane, and were in the little path.

"I don't like this narrow way, the brambles tear me," complained the Doctor.

"We are just at the Warren; look, there is a dove nesting in that tree. The gorse and broom bushes are full of linnet and bullfinch nests, and, oh, Doctor, you should see the rabbits bobbing about when the cool comes! Just now they are down in their burrows sleeping." "A dangerous place, this Warren, Mammy. The ground is riddled; one could easily stumble, break a leg!"

We sat down to rest. Silence fell between us. I could feel the Doctor and the Warren were not in sympathy. The Warren would not do any of the things that it did for me the other day. It went stupid, made me feel a liar. The birds were quiet; no rabbits scuttled; not even a cricket gritted his wings.

"Come, Mammy. We shall be late for Rest Hour." We went through the path and the lane. On the highway

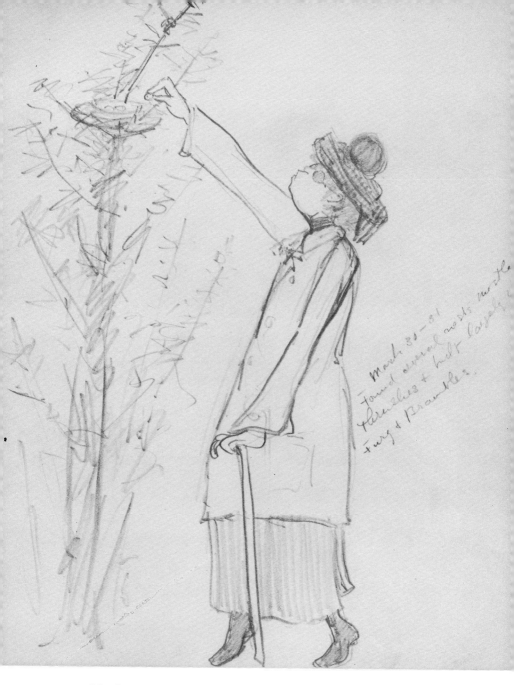

March 30-31
Found several nests, mostly thrushes', and built largely
in furze and brambles.

Doctor said, "You must not come to this place again. The walk is too far. The place is morbid."

"Morbid!"

"Solitary walking in woods is always morbid. Keep with the rest of the patients, Mammy. Go the shorter walks with them."

"That is morbid if you like!" I cried. "Disease, disease, always disease."

"They are forbidden to talk of their ailments."

"There are those who talk of nothing else, once they are out of the San's earshot."

I was suddenly dreadfully tired. I sat down on the roadside, my feet dangling over the edge of a dry ditch.

"That's right, Mammy, take it easy. I will hurry along."

As I sat on the edge of the ditch I was angry with pieces of me. I talked to my legs. I said, "You silly old legs, why must you tremble?" And to my heart, "You spluttering, silly heart. Why must you act up?" I smacked the leg that did not feel with my stick, then I got up and followed Doctor, Doctor who had gone back happily to her bottles and patients and stethoscope; to the inexorable law, the forced cheer of the San.

From that day Doctor McNair supervised my walks; she did not insist that I go with the others, but I must not walk far. I went into the little wood close behind the San. I discovered, too, an old orchard a short piece down

the road. The trees were twisted and moss-grown. The orchard was now used as a piggery. I was hunting bull-finch nests, and followed a lane that ran at the back of the piggery-orchard. I entered squeezing through a hole. I therefore did not see the notice up in front of the pig-farm: VICIOUS BOAR BEWARE! I heard a terrible roaring. The heavy beast was making straight for me. He had immense white tusks. I did not know any of the pig family could make such speed, could look so ter-rible! I could not run. I took a backward lucky step. It landed me in a deep hidden dry ditch. The bushes closed over and the·boar lost me. He leapt the ditch and tore past roaring. I lay there till the pig's dinner-time, then I crept back to the San late again. I was ill. I told them about my boar fright. They kept me in bed. Doctor McNair stood beside my bed. "Mammy, Mammy, why must you? Bed is the only place to keep you safe. Other patients don't go to these extraordinary places, do these queer things."

"I was only hunting a bullfinch's nest, Doctor Mc-Nair." There seemed nothing queer or extraordinary to me about pig-farms and rabbit warrens.

TEA TIME

Two little maids in scarlet, and very snowy as to caps and aprons, staggered onto the Circular Porch, one bearing a heavy tray. On it was an enormous "Brown Betty", nests of cuddling cups, plates of thick bread and butter. The other maid was provided with a folding table. Tea was served on the Circular Porch.

'Semis' waited for tea before going back to their rooms. Tea was optional. 'Ups' relished its reviving warmth on returning from their walks. Everybody scorned the bread and butter. They read cups and gossiped.

"Didn't 'Beautiful Cabbage' gobble of her favourite at dinner time? Four helpings no less!"

"Kate sneaked her cabbage over onto her mother's plate while the old girl and Miss Brown were having that deep discussion 'cabbage versus sprouts'. Was the old lady furious? Whew!"

"Saw, did she?"

"Rather! Shot the cabbage back onto Kate's plate with a deadly look, eyebrows tipped clean over the top

109

of her head! A Cranleigh funking! In a tone that would have cracked a bass viol she shouted, 'Play the game, Kate!' "

One gossip handed the other gossip a cup of tea. "One lump or two? Bread and butter?"

"One lump, and don't mention bread, butter or any form of food. Dinner congealed in cold gravy on my dressing table waiting to be eaten this very minute—supper only two hours off. Oh dear!"

"Same here, potatoes and spinach! Oh, my! Isn't Doctor's face . . . when there is food on your bureau . . . ?"

"It certainly *is*."

A plaid tam bobbed up the path. "Hello! News everybody! New brand of peppermint bull's-eyes in the metropolis of Stillfield. 'That 'ot they blisters,' says Ma Stocking." The speaker was always gay; her lungs were making satisfactory progress, her face brick-red, weather-beaten.

"How you can stuff yourselves with those vulgarities on top of our meals, I can't think!" sneered Mrs. Viney.

"They are for Jinny the donkey, not for us. Great fun, feeding peppermints to Jinny. Crunch, crunch. Jinny hee-haws to high heaven and rushes for the stream."

"Cold water on top of hot peppermint. Wow!"

"Jinny's a sport. Back she comes with her tongue and tail lashing furiously—asks for more."

Clang, clang, clang, the Rest Hour bell!

"Come on, let's attack our bureau dainties before Doc-

tor brings her face in." The little mob pressing through glass doors, clatter, clatter, down bare corridors, opening doors, shutting doors, silence. Every soul seriously sucking a thermometer and staring at the ceiling. Doctor's heavy tread, her small voice, "How are you? and you? and you?"

Gay answering chirrups, "Fine—fine, Doctor—just fine." The orthodox sanatorium lie!

A GOOD CRY

GRACE WILLET read the letter while lying upon her bed during the noon Rest Hour.

"How awful, you poor darling, incarcerated in that lung place. How can you bear it? but, for the sake of others—of course. *If* (scratched out and *when* substituted) you do come out, you will have to be so frightfully careful, careful for yourself, careful for others."

Grace Willet scrunched the letter, wrung it like wash, flung it under the bed.

"I am going to cry! simply howl. Don't care! I just shall!"

Doctor's step in the corridor. "I'd better wait till she has paid her visit, then cry, cry, cry I shall!" Doctor took the east wing first. The lunch bell had gone by the time she came to the west wing and Grace. Grace was still holding back her tears.

"Can't go to lunch bellowing!" She powdered her sharp little nose, brushed the reddish terrier-like hair back from dry burning eyes, went to table.

113

Dobbin said, "Where do you walk this afternoon, Grace?"

"Stillfield."

"Good, so do I."

Dobbin was a dull but steady talker. Grace Willet gave vague answers or none. She was saying to herself, "I want to cry, I want to cry!"

"You're walking too fast, Grace!"

"Don't care. Something I must do before supper."

Grace got the clean hankie, the lavender-water, arranged the hiding screen. Everything was to hand, everything except tears.

"They've teased to come all day. They shall come. I'll make them!" She tried and tried. Her eyes remained desert dry.

She even scrambled under the bed and retrieved the letter. Smoothed, read it from "My Darling!" to "Eternally yours". Not one tear.

Doctor came to pay her Rest Hour visit, sat toying with the lavender-water bottle. "Bonny wee bottle." She removed the cork and substituted her nose.

"A-a-a guid! Lavender grew in our old home garden." She returned the cork, continued her rounds.

"Lavender, lavender! Mother cutting the long stiff spikes." For nearly an hour Grace's homesick tears poured.

Supper! A letter torn to bits in the waste-basket—cold water—powder—clean hankie. Grace sailed down the dining-room, sharp little nose red, but very "up". Between munches Dobbin remarked, "You're all perked up again, Grace! You were dull company on our walk."

PICNIC

It was the San Event. Everything timed back to last year's or forward to next year's Picnic. Unless death actually had his finger poked into you, no one able to stand on his two feet missed the Picnic; otherwise he would be considered a funker.

The Picnic lingered on patients' tongues from one year to the next, a function prefaced by lively activity and anti-climaxed by sniffs and rheumatics.

Lungs are slow healers. Some patients took in many Picnics. They might go home between whiles, might have spells of tolerable wellness. Sooner or later it seemed, though, that they always came back for additional treatment, and perhaps during that come-back took in another Picnic.

Whiffs of preparation had been coming from the kitchen for days. (There were no secret smells in this place of open windows.) Boiled ham and spice-cake odours chased each other up and down the corridors. Mrs. Green, the San cook, had a Picnic formula. She

117

would no more dream of departing from it than a doctor would dream of stethoscoping a patient with the sugar tongs.

The great event was set for tomorrow. "Weather permitting" was a term unknown in the San. All weather permitted. Seasoned San patients passed through spring, summer, autumn and winter without comment. Weather was just weather, that was all there was to it. Patients accepted it like the animals. Newcomers might growl; nobody paid any attention to them. The wise patient blew on his fingertips, stamped his feet, and avoided the mirror; enough to see all the blue noses down the long, long dinner-table without looking at his own.

"Where do we picnic, Hokey?"

"Usual place."

"This is my first San Picnic."

"So it is! Well, then, beside the church."

"What, picnic in a graveyard?"

"Not exactly, we eat in a little strip of woods opposite, then cross to the graves."

"Rather . . . rather . . . isn't it, considering the condition of the picnickers?"

"Gloomy? Oh, my—no! The graves are the entertainment. You see, our patients cannot play active games or sing or do ordinary picnic stunts. They love to count the new stones. It is like visiting old patients. The nurses enjoy being among the ones they have nursed too. There is the old church for the *very* sick patients to sit

and rest in. San's Picnics have always been beside the graveyard. They would not be the same anywhere else."

"Then, it seems once corpses are in graves they are taboo no longer?"

Hokey frowned, "How you do put things!"

The Picnic morning was wet, rain drizzled. Picnickers took the weather in their stride. Those unable to walk were stowed away along with picnic baskets and Doctor McNair in the horseshoe bus. As cows with tails dangling and trickles of rain running down their sides hunch from stable to pasture, "Ups" ambled across the fields headed for the graveyard.

Dr. Mack was not a Picnic enthusiast but she clenched her teeth and was staunch to the San régime. It was said in the San that no one ever caught cold, owing to the elements. Colds were handed to you by a fellow-human. If a San patient got a cold he was isolated as if he had the plague.

Doctor Mack was stuffed with woollies till she was as shapeless as a bologna sausage. After everyone was set in the horseshoe bus, she staggered out of the San with what appeared to be a whole year's issue of the London *Times*. She rammed the space under the circular seat full of *Times*, murmuring, "Picnic sittings". Her eye caught the little basket I carried.

"Private lunch, Mammy?"

"The baby birds, Doctor."

"Surely, surely, wee birds must not starve because their mammy goes picnicking."

The bus stopped at the break in the old cemetery wall. All eyes ran across the graveyard, marking the white new stones among the old and moss-grown.

Doctor shepherded us into the sparse little wood across the road. "Eating before entertainment," she said.

The bus started back to the San. "One moment! James! Leave us the cushions."

James scratched his head, "Beg pardon, Doctor Mum. Is them new ones to ride from the station on nothin', so to speak?"

"Right, James. For the moment, the Picnic drove new patients out of my head." Doctor started rationing the London *Times*.

I hung the bird basket in a tree and the patients crowded round to see them gobble worms from a small pair of wooden tongs. I put the empty worm box back into my pocket. There was a general rush to help un-pack the picnic baskets. Doctor laughed, "For once my patients are eager for a meal!" She mounted an Eiffel Tower of London *Times* and tried to control the chatter of her teeth.

Thick cups of steaming coffee were handed round; our blue hands circled them; everybody wished they could submerge under the hot brown liquid. They grudged having to grasp with a stone-cold hand one of Mrs. Green's hefty sandwiches. Blobs of rain dripped off our

tams, sogging the bread and dripping down our collars. The men, who never wore hats, tossed the water from their hair with angry shakes; even so, dripping tangles of hair leaked into their eyes, and ran down their faces like floods of tears. This annoyed the men worse than the wet. Our laps filled with rain in spite of the London *Times* underneath us. It was found best to eat standing— one could drain better. Men shook their hair, women their tams, trees collected blobs specially to hurl down patients' necks. Nobody grumbled. It was the Picnic! Only the honest old stream by whose side we ate whimpered complainingly as it meandered through the wood. (A mean straggle of trees to call a wood. Just a huddling strip of grey boles which lay between the high road and a cow pasture.) The tree-boles half hid the pasture like a scant chemise. You saw the rail fence here and there between the trees; like lingerie ribbon it threaded in and out.

It pelted rain all the while we ate. We hurried the dishes into the baskets and stampeded for the cemetery. The women went into the church. Men drew hatless heads down inside their coat collars and huddled under a great beech tree among the graves.

The church was dark and squat. It smelled earthy and was full of creaks and crackles; pigeons mourned in the belfry, emptiness shouted from pulpit, choir, organ and lectern. Our wet clothes made the varnish of the pews smell. We were silent till Jenny, choking back an

unholy laugh, said, "I'm stuck!" and wrenched herself free with a click. We were all stuck! They had recently revarnished the pews. The backs of the seats were hairy from our woollen clothes.

A pale little sunbeam straggled up the aisle. Miss Dobbin tiptoed from the pew to see if it were real. The sunbeam leapt over her like a happy pup. She beckoned and we filed out of the church just as the little band of men broke and scattered among the graves.

Up and down, up and down, between the tombstones we crept in single file, reading names. The soil of one grave was newly turned; it had no headstone but the wreaths on it were still alive.

"Whose?" someone whispered. Nurses pretended not to hear. Death in that grave was too new to mention. Mentally I fitted the cough I had missed in the east wing for the last few days into that grave.

We all stood round a tiny grave having a wreath of bead immortelles under a glass globe and a white marble cross at the other end. On the cross in gold lettering we read, "Petit Pierre". Near the tiny grave was a long one, "John Withers, aged fifty years, erected by his master and friend." "Why Hokey," I whispered, "I thought John was old, old."

"He suffered," she said, and smoothed her hand over the top of the solid granite.

Sun strengthened; the earth steamed. A storm thrush settled in the top of the great beech tree and, as is his

way after storm, shouted hallelujahs! The rain was done; thrushes and blackbirds, larks and warblers, sang as if their throats would burst. "Cuckoo, cuckoo!" The monotonous note was flung from graveyard to woods, back and forth, back and forth, with tombstone monotony. The brook had taken on a happier tone, replenished by new waters. It sang more contentedly as we leaned over the little bridge spanning its waters and waited for the San bus to pick us up.

The San's good-looking boy patient was at my elbow, leaning over the rail. We were both gazing into the meagre little wood.

"Remind you of Canada?"

"No! Oh, no!"

The bus drove up. The picnic baskets were stowed in. Patients mounted the two iron steps to take their seats on the cushion. Flap, flap, our wet skirts smacked against the iron step. Our woollies smelled like wet sheep.

We were hustled to our rooms at once. It was the evening Rest Hour. We climbed into dry clothes and lay upon our beds. Doctor, much more serene and comfortable than she had been during the Picnic, visited from room to room.

"Did you enjoy the Picnic?"

"Oh, immensely."

To the next patient, "Did you have a good time at the San Picnic?"

"Tip-top, Doctor!"

So, up and down the corridors everyone lay upon his bed and lied. Some of us wondered, "Next year will the picnickers be reading my name on a stone? Will the next be me?"

The white owl hunted early. Her brood in the hollow oak tree at the back of the San were voracious. She swooped up and down the terrace, peering into each lighted room, asking with her great rolling eyes and her soft enquiring voice, "Who? who? who?" The question we asked ourselves.

When the owl "who'ed" Mrs. Viney she hurled her shoe at its blinking eye, with lively vehemence, but missed. Nurse Maggie retrieved the shoe from the terrace, grumbling a little at the wet and dark.

NOBODY'S PATIENT

HOKEY had appendicitis; went up to London for oper-
ating; left me high and dry as a beach-log cast beyond
flood-tide. I was nobody's patient and was again a
'Down' confined to bed.

When Bunker's mumpy face and fallen arches shuf-
fled round my room I feigned sleep.

Ada's violence shattered all sham. Bang, bang, bang,
things crashed till Matron came to look into it.

"Got a headache?" she asked me, not appearing to
watch Ada.

"Awful. When will Hokey be back, Matron?"

"Soon now." She smoothed my pillow, held my
wrist a minute. The mop handle g-r-r—ed down the wall,
smacked the floor. "Gently, Ada, gently," Matron said.

But Ada could not be gentle, her make-up was row.
A spider ran across my bureau. "A-ow!" she screamed
and flung her dust-pan clattering after it. When she saw
a harmless insect she yelled as if it were a lion. Doctor
met a red-faced Ada rushing down the corridor! I begged,
"Couldn't I please have any other nurse? Even an 'Odd
Jobs' rather than Ada?"

I was handed over to Nurse Bandly, spontaneous like-

able Bandly, who knew how to both laugh and cry, tall Bandly swooping down to gather you into her arms, her starched bonnet strings sawing you head from body. You did not see Bandly's tears, only heard their wetness in her voice when she was sorry. Bandly could not be my nurse for long, because a new man patient came and Bandly settled the men in better than any other nurse.

I fell then to the ministrations of that holy nurse, Maggie. That is, her energetic body rattled around my room occasionally, stirring the dust, but her heart was all for the Cranleigh boy at the end of the corridor. She grudged every moment she had to spend away from him. He was a bad case.

If I wanted to claim Maggie's attention I said, "D—n!"

Maggie reared like a scorched caterpillar, bolted back to her sick boy, told him about the d—n. He told 'Beautiful Cabbage', his mother; she passed it on to Kate. Kate spread all over the San that I blasphemed and was to be avoided. It came back to me and I said, "D—n, darn, d—n!!! Let them all go to the devil and sit on their hats! I don't care!"

When next Maggie came into my room, I sang,

"I am not very long for this world,
My white wings will soon be unfurled,
Old Peter will say, hoorip and hooray!
For Mammy is coming today, today,
For Mammy is coming today!"

That finished me with Maggie.

128

DEATH

THE tap on my door was gentle but firm. A strange nurse entered and stood at the foot of my bed.

"I have come to do you up."

"Have you?" I said, a little puzzled. "Aren't you the Special who came from London to look after the very sick boy in the west wing?"

"He does not need me any more."

"Tell me, was it dreadful?"

"No, quite easy, poor laddie."

Nurse Patterson got my fresh day gown, the water, soap and towels. She seemed to know where everything should be without asking. Item by item she laid everything ready. You could tell she had trained well. Our nurses were efficient enough in San nursing, but they had limitations. When anyone was frightfully sick Specials came down from London to nurse them.

Nurse Patterson did not talk as she worked. I liked her silence; it made me ask, "I want to know about that boy's dying. I have seen dead people but I have never seen anyone do it. Is it terrible? Do they mind? I

129

have often wondered how it would feel to face death. Here death is never mentioned though several patients have died since I was in the San."

"In twenty years of nursing I have seen many die, many beautifully, some sadly, a few terribly," said Nurse Patterson. She told me something of each kind. She worked as she told; I listened intently. You felt it earnestly true, not dreadful as I had thought.

"Thank you, Nurse. I have heard a lot in Church and in Sunday School about death, nothing about the practical side of dying; I would not have dared ask any-one in the San. Death is sort of a disgrace here, some-thing to be hidden, never mentioned. You miss a cough. The room is being got ready for a new one. The old one's name seems to die with him."

Nurse Patterson said, "Don't dwell too much on death, child. Death has a way of preparing for itself. The San people would probably be angry with me for talking to you of these things."

"I shan't tell. My nurse is away sick. I am nobody's patient, just done up by anyone who has time."

"You are going to be mine till your nurse comes back. I am filling in."

"Oh, I am glad. I like my nurse tho', and she will understand more when she comes back, because she has felt being sick."

"I expect she will. Sometimes I am sorry I trained. I have a little sister who wants to be a nurse. I am trying

to dissuade her."

"Why? Are you sorry about yourself? Why want to stop her?"

"My little sister is a joyous being. I am afraid she may lose her joy, or that she may grow hard."

"You haven't grown hard. Have you lost joy?"

"I don't know," said Nurse Patterson, "I don't know." Tears came into her eyes. Doctor Bottle tore into my room in her cyclonic way. "Nurse Patterson, you are to special No. 15 in the east wing." I never saw Nurse Patterson again; again I was nobody's patient. Hokey was back but not working. I drew a picture of a girl preparing to commit suicide in a water-jug. One hand was holding up a very small plait of hair so that it should not get wetted. The other hand steadied the jug; under the drawing I printed, DESPERATE.

Hokey came back. "Don't do it again, Hoke."

"Can't. Nature gave us only one appendix."

SCRAP'S CHILD

SCRAP's baby was nervy and fretful. She was brought occasionally to the San to visit her mother. Scrap had seen so little of her child, since the babe was old enough to take notice, that the child preferred her nurse. The woman spoiled her. Scrap groaned when the child turned away, but she dared not offend Nurse. The woman cared well for the infant.

Scrap and I had become very good friends. After supper in the evening my door would open—such a very little way, it seemed, when you remembered it was to admit an adult. I tossed a pillow up on to the top of the high gilt radiator that was always stone cold. Scrap climbed, took a bit of wool knitting from her great-coat pocket, told me the San news and little bits from her home letters. I read her pickings from my Canadian ones.

This night Scrap was full of one subject; she braced her toes against the edge of my bed and began excitedly, "What do you think?"

Scrap had been down-hearted lately. I was glad to see her animated.

133

"Has Doctor Sally given you permission to go home?"

"Almost as good! She is going to let me have baby here. Nurse will come too, of course, to look after baby. We will have the big room at the end of the west corridor. Baby in a cot close to my own bed. Just think! Aren't you glad for me?"

I was silent. Scrap looked keenly into my face.

"You don't think it good?"

"I do not, Scrap. I don't care what two hundred and fifty Bottles say. Fretting lungs don't heal. Lungs are all Doctor Bottle cares about. She is letting your baby take risks because she wants to add you to her list of cures."

"I want my baby."

"Several other mothers in the San doubtless want their babies too. They'll enjoy having yours to dandle. How Dobbin will kiss her at every opportunity!"

Scrap winced! After a moment's quiet she asked, "Shall I recite?"

"Please do."

Her head was full of memorized odds and ends. We often wheedled half-hours by in this way; odd bits of poetry, little bits of prose drifted our thoughts away from San monotony. We were so surrounded by open air, it was easy to fly away on phrases, words that caught our fancy, travel through dark and space, leaving our bodies, our ailments and disappointments in the San. The bell for Turn-in rang. Scrap got down from the radiator.

Reunion of
the Morsel & the Babe.
May 1st
Anticipation

Oh Baby!
Realization

"Good-night. I am not bringing baby here."

"Good-night, little Scrap." She had thrown herself across my bed. For a moment things reversed; I, who was older than Scrap by several years, just then was her baby. Years did not count. Scrap needed something human to hug at that moment. Her husband was a cold man. He had never kissed Scrap nor allowed her to kiss him, since he learned she had T.B. He did not want her home, did not want every window in his house open to all the winds of heaven. I doubt if he would have allowed his child to go to the San. (Scrap had not told him yet of Doctor Bottle's plan.) Scrap and I had a tiny cry, a big hug. She went to her room.

Life in the San did queer things to us. Was it our common troubles and discomforts? Or was it the open —birds, trees, space, sharing their world with us—that did it? I don't know.

TWO ENGLISHWOMEN

THEY came to the San together. Now, they were leaving together. During their stay in the San they had stuck close to each other as damp postage stamps.

Miss Bodwill was tweedy—raised mannish—batched with a brother.

Feminine woollies clung softly natural to Nellie Millford. She wore a little jewellery, had a titled aunt, and gloried in pretty feminine things.

Dr. Mack liked these two women. They were welcomed in her sitting-room at all times; she joined them in their walks. The patients rolled jealous eyes and whispered, "A house doctor should not have favourites, should mix with all, or remain solitary."

Could one see Dr. Mack hob-nobbing with the stolid Dobbin, with Mattie Oates, linking arms with dull, foamy Mrs. Viney? I could not.

The three tall women continued to walk together, looking calmly over the tams of the cat-eyed. They went on having their good little times. Summer passed.

By late autumn Nellie Millford was well, Miss Bodwill

137

well-with-tolerable-care! They left the San. Doctor Mack was lonely. She would not have admitted it, but I saw the sag of the solitary about her. The two women came to bid me good-bye.

"I am off to Scotland with my Aunt, Lady Broadley," said Nellie, twiddling an engagement ring. "I am going to be married." Suddenly her arms were round me, hugging! "I'm well and frightfully, outrageously happy!"

Miss Bodwill wagged a cropped head and two tweed arms into my room. "So long! Good luck!"

The London post brought me a delicious box of foolishness from the two women—baby birds that gaped, frogs that leapt, woolly things that made noises—together with two letters containing things Nellie Millford and Miss Bodwill had left unsaid when they came to bid me goodbye.

Nellie wrote, "I am almost ashamed to be as happy as I am. Six months ago I went to the San desperate. Now! Hurrah for Dr. Sally B."

"It is grand to be home again," wrote Miss Bodwill, "to be puttering about a house and garden. Brother-men are hopeless housekeepers."

I had not realized that under cropped hair and mannish tweeds Martha Bodwill was all woman.

CHRISTMAS

CHRISTMAS descended upon the San as an enormous ache, a regular carbuncle of homesickness with half a dozen heads.

A super-cheerful staff festooned greenery on Christmas Eve. Overworked stomachs groaned at the enormity of Mrs. Green's preparations.

The post-bag went out from the San stuffed with the gayest of Christmasy letters written by patients practically drowning in tears. Beside each bed was a little pile of cards addressed to various comrades in exile. Nurses would deliver them on breakfast trays, jokey nurses lit with fraudulent gaiety—tainted exiles, nevertheless, homesick as the rest of us.

Hokey, gathering my Christmas cards, caught her breath, dumped the pile hastily from chair to apron pocket, left the room. I tried to remember whose name was on the top of my pile, the name that choked Hokey. For the moment I could not. A horrible noise began out on the terrace. Four men and two boys came reeling past our rooms, singing a carol in six different keys,

peering impertinently into the lighted rooms. Everyone switched into darkness, became headless bumps in beds.

While the boys screeched a duet, the four men paraded up and down the terrace, thrusting a tin cup into the rooms at arms' length, rattling a penny to the tuneless jumble of tipsy whimpering. " 'Ave a 'eart for the poor Waits. What for the Waits?" Between each shake of the cup the men whined. Receiving no response the Waits grew angry, insulting. They had been drinking. They stood on the terrace silhouetted against the night, refusing to go till they got money. Nurses took the tin cups and carried them from room to room. Everyone was angry at hearing the dear old carols insulted on drunken tongues. A few pennies clanked into the cups to induce the Waits to go. Religious little Jenny I could hear crying through the wall. Susie Spinner on the other side of me was shouting one of her tiresome jokes to Hokey through the open transom.

Christmas day broke dark and windy with little flurries of snow. The big dinner was set for five, with a light lunch at noon when every patient was permitted to eat as much or as little as he wished. All patients that could sit up were dragged to the festival table. If they could not walk they were taken in wheel-chairs. Complete "Downs" were served decorated trays in bed.

Log fires burned in the grates at either end of the long dining-hall. The corridors smelled of pine boughs, holly prickled in corners, mistletoe was taboo. (T.B.'s

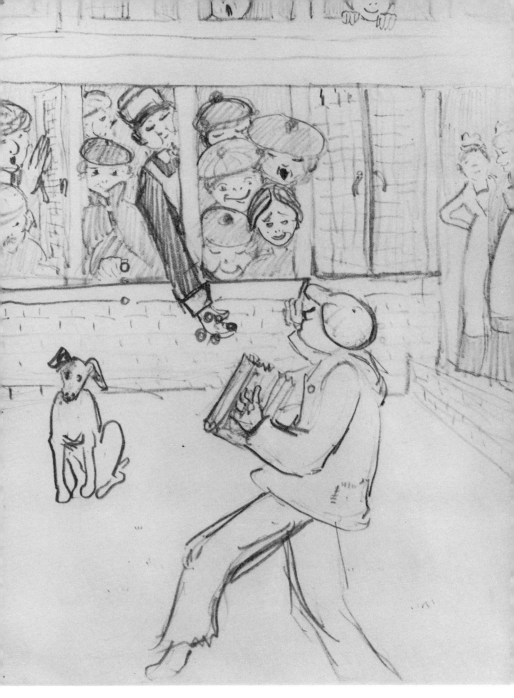

April 10
Enormous excitement in the San. Boy with concertina
arrives. Pennies scattered in all directions. Large per-
centage of high temperatures that night.

are not supposed to kiss.) Scarlet-dressed maids flittered about like robins. Through the steamy kitchen Mrs. Green's voice boomed like a deep sea liner in a fog.

We wore our usual woolly garments with a sprig of holly stuck on us somewhere. Monster turkeys, juicy and rosy brown, were dismembered at the side-table by Doctor Mack and Matron. The turkey helpings were heaped about with sauces and dressings. The pudding burned with brandy-fire. The sprig of holly on top crackled. At the end of the meal, toasts were drunk in a pink liquid, non-alcoholic. All plates were emptied because they did not have to be and because it was a splendid dinner. Mrs. Green was called for. They pulled her into the dining-room, scarlet with embarrassment, little trickles of sweat meandering down her cheeks. She dare not mop for fear of slopping the pinkish liquid in her glass. She just got redder and redder, bracing herself against the swing door. It took several maids to keep the door taut.

"Mrs. Green! Hurrah!" All solemnly drank.

"Speech, Mrs. Green! Speech! Speech!"

It was not possible for her red to go redder. Her hand shook so violently she had to entrust the pink liquid to a maid. Mrs. Green's kind blue eyes embraced us every one. She burst out with ill-suppressed sobbing.

"Pour souls! Poor souls! God bless youse all!" Then completely overcome she ordered the maids to give way and let her back into her kitchen.

Chairs shuffled; we moved into the sitting end of the dining-hall for entertainment. Gathered around a real fire, comfortable, we were strangers to each other. In the open, taking treatment, at table struggling with food, we were comrades, intimates; sitting cosy, warm, luxurious, we were strangers.

Lung patients turned faint from unusual warmth and were compelled to move to the open windows; sitting quietly there, they watched the falling snow.

A Christmas paper had been preparing for several weeks. Every San patient had contributed something. It was to be read aloud on Christmas night.

The Reverend Brocklebee put on his spectacles, moved up under the light, cleared his throat, spread the paper.

My contribution was called, "Matron's Dream". It was a skit on the names of all patients and staff in the San. In the middle of my very best sentence the Reverend Brocklebee stumbled, peered close, reddened, skipped.

Fool! What a mess he had made of it! Couldn't the man read? Or had some name been purposely omitted? Miss Ecton had not been at the dinner-table. She was up and about yesterday. I remembered Hokey's face as she pocketed my cards. Miss Ecton's name had been on top. Now I remembered. It was the last card to be addressed.

We did not have a Christmas tree but there was gift-giving of sorts. Skeletons of dressing screens without their drapery were placed at one end of the room. On

143

these hung a multitude of little butcherish brown paper parcels (each might have contained one chop). The parcels were knotted and tied with white butcher-string. Each patient was blindfolded, led to the rack, to choose his own parcel, silly little gifts aimed to provoke a smile. The San meant well.

When we had all taken, each nurse stepped up and took for her bed patients.

"Hokey, you forgot Miss Ecton." I watched her close-ly. There was sham behind her casual, "So I did," and stepping jauntily she took another parcel. Hokey couldn't act well.

At nine o'clock we went to our rooms. Christmas was done, and nobody was sorry.

Hokey came to tuck me up. "Hokey, I know. You need not lie. Tell me about Evelyn Ecton. I chatted with her last night at five o'clock on the porch."

"She was dead at six—haemorrhage," Hokey choked.

Evelyn Ecton had come to the San about the same time as myself. We both were Hokey's patients.

Yesterday I had appeared on the porch, first time up in two months. Evelyn Ecton coming back from her walk greeted me, "Hello, I've been up, you down. See-saw, see-saw." She laughed. All Christmas Day she had lain in the San morgue awaiting burial. We Christmased within earshot of the little brick morgue but Evelyn Ecton's self was away. Our forced merriment did not disturb her rest.

GOODBYE

PATIENTS drifted into the San, paused, and drifted out again. Some went coffined, some rode triumphant in the horseshoe bus, many to return later for further treatment. Always secrecy regarding goings. Were they coffined or horseshoe bus goings? Sometimes the San left us uncertain. A patient just disappeared; tight-lipped and evasive were the staff over the word "death".

"Gone home," they said vaguely, and left us to wonder. The San walled death about, hid it from us as if it were an indecency.

All my contemporaries were gone from the San, some one way, some the other.

Scrap was back home with her baby. Kate Cranleigh had recovered and was home with 'Beautiful Cabbage', who now that she had her daughter home and no son to visit dined with us no more. The Cranleigh boy's going was one of the mysterious departures, like John Withers, Miss Scrobie, Evelyn Ecton, little Jenny, and the rest. What big fools the Staff took us for!

Miss Dobbin's patient chewing triumphed. Mrs.

145

Viney, who never did accept the San code, had antici-
pated pleasurably a recital of her symptoms when she
got home only to find that then she had no symptoms
left to tell.

I had been in the San eighteen months, was back in
bed, losing ground. A new treatment was suggested.
Dr. Bottle promised to write my people in Canada. Month
after month she forgot.

Each week Dr. Mack asked, "Mammy's letter, Dr.
Bottle?" and Dr. Bottle would run past my door, too
confused to face me. I despised her. Had my check
from home not come regularly she would have remem-
bered. Had I been titled or important she would have
remembered. I was only a student. Hokey, Matron,
Doctor Mack humoured me like a pup which is about
to be bucketed. They were gentle, did some spoiling
of me.

Lying helpless, I worried about my birds, calling,
calling. All the old stand-by patients were gone. They
were at the mercy of this one and that. The new outfit
were strangers to me and to the birds. At last it was de-
cided to try the special treatment.

"Doctor McNair, may I get up?"

"You are not able, Mammy."

"Something I must do."

"Your nurse is here."

146

"No one can do this but me."

The birds came to my hand; one by one I put them into a box. Their round trusting eyes pierced me. I took the box to my room.

"Hokey, ask Doctor to come."

She came to me hurrying.

"The birds, Doctor. There in the box. Chloroform them."

"Mammy!"

"Quick, they are waiting."

"Free them, Mammy!"

"They do not know freedom. Villagers would trap them—tiny cages—slow starvation. Suppose they stole a berry from Miss Brown's garden! Broken necks, fertilizer for cabbages! Please, Doctor. I love them too much." The big overruling woman obeyed.

It seemed the San code enveloped even bird-death. No allusion was ever made to my birds' sudden disappearance. If possible, the staff were extra kind to me. I had been in the San more than a year. I, too, had learned San silence. I did not mention birds for Canada again. I could not.